AFRICAN AMERICANS
IN
GLENCOE

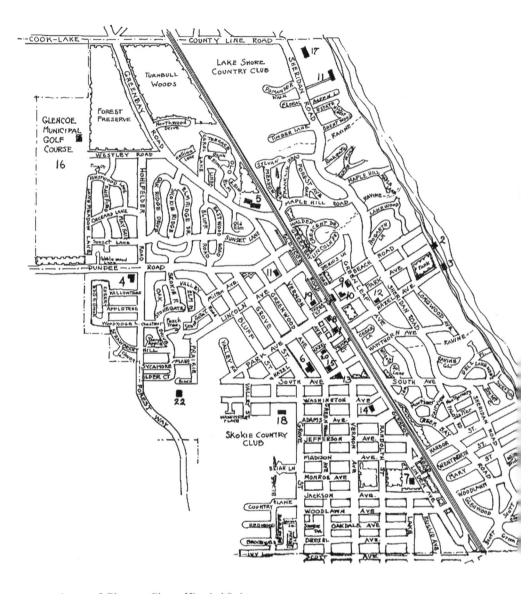

A map of Glencoe. *Glencoe Historical Society.*

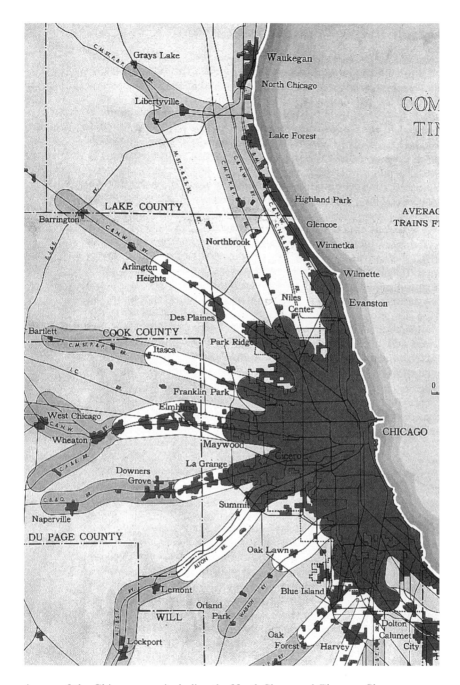

A map of the Chicago area, including the North Shore and Glencoe. *Glencoe Historical Society.*

AFRICAN AMERICANS
IN
GLENCOE

The Little Migration

ROBERT A. SIDEMAN

Charleston · London

THE
History
PRESS

Published by The History Press
Charleston, SC 29403
www.historypress.net

First published 2009

Manufactured in the United States

ISBN 978.1.59629.814.9

Library of Congress Cataloging-in-Publication Data

Sideman, Robert A.
 African Americans in Glencoe : the little migration / Robert A. Sideman.
 p. cm.
 Includes bibliographical references.
 ISBN 978-1-59629-814-9
 1. African Americans--Illinois--Glencoe--History. 2. Glencoe (Ill.)--Race
relations. 3. Glencoe (Ill.)--Biography. I. Title.
 F549.G56S53 2009
 977.3'1--dc22
 [B]
 2009027211

Notice: The information in this book is true and complete to the best of our knowledge. It is offered without guarantee on the part of the author or The History Press. The author and The History Press disclaim all liability in connection with the use of this book.

Contents

Preface

We have one black trustee, and I suppose we will always have one black trustee.
 —Carol Hendrix

W hen Carol Hendrix spoke those words in 1977, it seemed a reasonable prediction. African Americans had lived in Glencoe, Illinois, for nearly a century, their population numbers were relatively stable and more blacks were taking part in community affairs. I served with African Americans on the village caucus—Glencoe's nominating committee for local office—and I know that our work was strengthened by the diverse views represented in our deliberations. I felt a good deal of pride in the composition of our caucus, which in that sense was unusual if not unique on the North Shore.

As it has turned out, however, Carol Hendrix was wrong. Recent years have brought changes to Glencoe's appearance as smaller homes and even neighborhoods have given way to new, generally larger, construction. These new realities were reflected in census figures as Glencoe's black population registered a sharp decline from 1990 to 2000, a drop that has probably accelerated since then.

It seemed a time to take stock. I discovered that while little has been written about Glencoe's African American heritage, there were ample historical resources available to tell the story from the very first days and even before. What ensued was truly a shared effort, one that, at least for me, represents the best of community spirit in a small place.

Acknowledgements

I am grateful to people at many institutions who provided important assistance: Peter Scalera, Village of Glencoe; Nancy M. Symonds, Glencoe Park District; Reverend Donald G. Harwell and Jerri Haith, St. Paul AME Church; Deb Shamlin, Glencoe Human Relations Forum; Barbara Joyce, Sacred Heart Parish; Anne M. O'Malley, New Trier Township High School; Kevin B. Leonard, Northwestern University Archives and a Glencoe native; Tina Reithmaier and Ginger Frere, Newberry Library; Dennis M. Kass, Chicago Urban League; Cynthia Fife-Townsel, Vivian G. Harsh Collection, Chicago Public Library; Philomena Hale, office of the Recorder of Deeds, Cook County; Jeanie Child, Circuit Court of Cook County Archives; Marc Thomas, Northeastern Illinois Planning Commission; Raymond Collins, Illinois State Library; William F. Holton, Tuskegee Airmen, Inc.; and Melody H. Morris, Horatio Alger Association. Also thanks to Helen Gallagher of Computer Clarity, Glenview, and Paul Lane of Photo Source, Evanston.

Many individuals also provided important assistance: Morris Barefield, Bruno Bertucci, Jennifer Bluford, Roland B. Calhoun, Wendell Carpenter, Karen Ettelson, Gloria Foster, Richard F. Friedman, Trisha Gregory, Carol Hendrix, Kenneth W. Jost, Nancy King, Robert B. Morris, Harold Neal, Sarah O'Kelley, Eddie O'Kelley, Wilson and Effie Rankin, Stanton Schuman, Frank E. Sublett, Charles R. Thomas, Louise Van Horne, James O. Webb and Janet Williams.

Peggy Hamil and her colleagues at the Glencoe Public Library handled each reference request with the professionalism, patience and good humor that help make their institution a source of great pride for Glencoe.

Acknowledgements

Special thanks to Ellen Shubart and her colleagues at the Glencoe Historical Society, who provided ready access to local history, and to Lonnie Barefield, who provided invaluable assistance from the very beginning.

And to my children, Laura Rissman and Roger Sideman: my thanks and gratitude for their continuing love and support.

For Sale
Choice Residence Lots in Glencoe at $100 Each.

On easy terms—$15.00 cash, and $5.00 monthly. Title clear, abstract and full warranty deed given to each purchaser. Customers taken to see lots free of charge every week day at 10:45 o'clock a.m., and on Sundays at 8:30 a.m., from C&NW Railway depot, corner of Kinzie and Wells Streets.

 It is time for the colored people to be buying their own homes and stop paying rent, to be independent of landlords, and here is an excellent opportunity which every poor man can accept.

<div align="right">

–advertisement, The Conservator, *Chicago, 1883*[1]

</div>

The Glencoe Homes Association was organized for a civic purpose and not to make money. Those who first subscribed $1000 never expected to get it back; they were performing a civic duty and protecting their own property…

<div align="right">

Real Estate Investor of Chicago, *1927*[2]

</div>

The old suburb as a small town is history.

<div align="right">

–Historic Illinois, *2006*[3]

</div>

"There Is No Suburb Like Glencoe"

Europeans began to settle the Glencoe area in the 1830s and 1840s. They were attracted to the rolling land on high bluffs over Lake Michigan, laced with ravines and, unlike the open prairie to the west, largely wooded. Farmers from New England and the British Isles came early, followed by others from Germany. They cleared portions of the land and established homesteads, and with the formation of New Trier Township in 1850 they organized the first local government. Five years later, the Chicago and Milwaukee Railroad arrived on its way to Waukegan, leading to increasing numbers of homeowners and real estate speculators.

In 1868, a group of investors led by Dr. Alexander Hammond platted a tract of some four hundred acres they called "Gurnee Farms" or "Glencoe Farms." Their development extended from South Avenue north to Beach and Dundee Roads and westward from Lake Michigan across the railroad tracks to what was then called the Skokie Marsh, or simply "the Skokie." The Glencoe Company, as the investor group called itself, designed a community of fifty blocks of residential properties, a business district, a depot, a school, a lakefront park and a church.[4]

The village of Glencoe that was incorporated the following year, however, encompassed not only Glencoe Farms but other developments as well. South of South Avenue and east of the railroad there was the predecessor to Glencoe known as Taylor's Landing or Taylorsport. Anson Taylor, the area's first white settler, arrived with his family in 1834. Taylor first settled on the bluff at Woodlawn Avenue but soon moved his home westward to the Green Bay Trail. There he established an inn, LaPier House, at the foot of Harbor Street that also functioned as a tavern, general store and shipping office for Taylor's Port. Nearby was Taylor's warehouse for logs and cordwood, close to the five-hundred-foot pier that he and his neighbors built to take

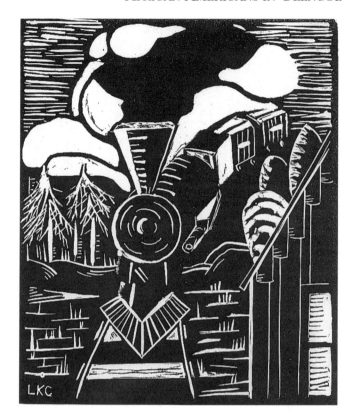

The Chicago and Milwaukee Railroad came through Glencoe in 1855 on its way from Chicago to Waukegan, as depicted in one of a series of linoleum cuts designed by New Trier High School students in 1932. *New Trier Township High School Archives.*

advantage of lake traffic. Over the years, Taylorsport grew into a small but established community.[5]

South of South Avenue and west of the railroad lay another section of the new village, where the ownership was more fragmented and the land less developed. Evidence of its farming origins remains in a street plan that follows section lines rather than the shoreline and railroad that dictated the rest of early Glencoe. Members of the Taylor family owned property there, too, among them Anson Taylor's son-in-law Michael Gormley. A native of Ireland, Gormley was also an early arrival, first farming and then, sensing the opportunities in land development, subdividing his property south of South Avenue and west of Grove Street into residential lots. (Naming the streets after presidents—a roster that once included Harrison and Tyler, too—was probably Gormley's idea.) Gormley, a forceful and determined man, also served in many public positions. He helped organize New Trier Township in 1850, and in 1877 he was elected one of the first village presidents of Glencoe.[6]

Seeing the potential in an attractive, well-located new community, other developers purchased land in the "south end," as the neighborhood came

The Little Migration

Walter Gurnee, the railroad's president, built his own home just across from the Glencoe depot. Gurnee's house still stands 150 years later. *New Trier Township High School Archives.*

By 1840, Anson Taylor's LaPier House was a regular stop for the stagecoaches that plied the Green Bay Trail. *New Trier Township High School Archives.*

Taylor's Port, at the foot of Harbor Street, was a shipping point for logs and farm produce bound for Chicago. *New Trier Township High School Archives.*

to be called. (The predominately German farming area toward the county line likewise became known as the "north end.") One was Morton Culver, a lawyer and Union army veteran who moved his family from Chicago shortly after the Fire of 1871. Culver's father first came to the city in 1833, later purchasing large tracts of real estate in northern Cook and Lake Counties. Morton Culver was born in Niles, Illinois, in 1841. He was educated in the Chicago schools and at Northwestern University, where he earned a bachelor's degree in 1867. Culver went on to Northwestern University Law School, and after graduation in 1871, he was admitted to the Illinois bar. Two years later, he purchased an existing subdivision just east of Michael Gormley's property that extended from South Avenue south to Jefferson and from Vernon west to Grove.[7]

Later, Edward Hartwell, a Chicago manufacturer, purchased the blocks east of Culver's property, running from South Avenue south to Jefferson and from Vernon east to Railroad Avenue, now known as Green Bay Road. Hartwell promptly sold some of his holdings to Morton Culver, who

frequently traded properties with his fellow developers while providing mortgages to homeowners across southwest Glencoe. South of Hartwell's Addition was a tract owned by Christopher Uthe, a Civil War veteran and early settler who, like Gormley, took part in township affairs from the first days. Uthe's property extended from Jefferson Avenue south to Jackson and east from Vernon Avenue to Lake Street. Before long, African Americans would settle in each of the three subdivisions.[8]

In Glencoe's early days, decisions on bestowing or withholding public improvements for the benefit of one development or another became critical matters with much at stake. The authority for such decisions resided in the village president and six village trustees, who also controlled taxing and licensing, education and public services and sales and purchases of local streets and other public lands. Since the leadership of the new community included recently arrived real estate entrepreneurs—struggling with sales that lagged from the 1870s almost until the turn of the century—as well as longtime settlers, some of them still farming, it took little time for factions to form and political machinations to follow. To make matters worse, the trustees soon divided tiny Glencoe into wards, a scheme that enabled the sparsely settled sections to control the board at the expense of Glencoe Farms, where most residents lived.

This led to even more conflict as shifting factions continually jockeyed for power in maneuvering that reached a peak at the annual village election—all trustees and the village president then served terms of one year. In that era in Glencoe, voters learned neither the names of the candidates, nor who had selected them, until they arrived at the polls, while ballots were frequently "lost" on the way to counting amid charges of phantom voters and elusive boundaries. By 1878, Morton Culver had already served one term on the Village Board at the same time that Michael Gormley was president. Under the new system, the south end became the Third Ward. In 1880, Culver and Gormley, by then bitter rivals, faced off for trustee and actually tied.

It was shortly after that election—the final one under the ward system—that Morton Culver convinced a number of black families to settle in his neighborhood. His reasons for doing so, and how he accomplished it, remain unclear; by one account, his intention was to attract neighbors who would provide him an assured base of electoral support in his continuing battles with rivals such as Gormley. If so, the results were meager: Culver was elected to the Village Board only once again.[9]

He may have had other motivations, however. Culver certainly recognized that Glencoe lay in the midst of a desirable residential district that, as it prospered, would provide increasing opportunities for household-related

Michael Gormley, son-in-law of
Anson Taylor and an important
property owner in southwest Glencoe.
Glencoe Historical Society.

employment. As an active member of the community, he would have
been in a good position to assist his new neighbors in securing jobs and in
encouraging other black families to join them.

Culver was also among the first to recognize the importance of quality
education to the new community. He devoted much of his first term on the
Village Board to school matters, frequently imploring his fellow trustees to
provide additional resources for the Glencoe School. Culver's wife, Jenny, was
a teacher and also a college graduate, having received the degree of Mistress
of English Letters from Brookville, Indiana Seminary in 1862. When the
Glencoe Board of Education was formed in 1896, Jenny Culver served as
one of its founding members. As leading figures in the community, Morton
and Jenny Culver certainly understood that as a result of their decision,
from then on prospective residents considering Glencoe would encounter an
integrated school system.[10]

Two chapters in Morton Culver's past might offer additional clues.
One is that from 1867 to 1870, Culver served as principal of the William
Jones Elementary School at Harrison Street and Plymouth Court, which
at the time enrolled the largest number of African American students
in Chicago. This gave Culver a significant connection to the city's black
population that may have been useful to him when he decided to pursue
his plans for Glencoe.[11]

The Little Migration

Morton Culver sold the first property to an African American family. *Louise Culver Van Horne.*

The other clue is that Ferdinand Barnett, the third African American admitted to the Illinois bar and a founder of *The Conservator*, Chicago's first African American newspaper, began his legal education by reading law with Morton Culver. Nothing else is known except that even after enrolling at Northwestern University Law School in 1876, Barnett continued to study with Culver. Barnett, who went on to become a nationally renowned civil rights leader along with his wife, Ida B. Wells, remained close to *The Conservator* even as he devoted increasing time to his law practice, so that he and the publicity he could generate may have been instrumental in creating awareness and support for Morton Culver and his Glencoe venture.[12]

Morton and Jenny Culver's public spirit was reflected in their children. One of their sons, Morton T. Culver, settled near his boyhood home on Washington Avenue. Long active in the community, Morton T. Culver was elected president of Glencoe in 1900 and later served as village attorney. (Another son became, at age twenty-two, Northwestern University's first full-time football coach. Alvin Culver was in his second year of coaching in 1896 when Northwestern began playing under the rules of the newly organized Western Conference, forerunner of the Big Ten.) The Culvers' oldest daughter, who became a physician, remained in the family home. Dr. Eugenia Culver treated black and white patients from her residence on Washington west of Vernon that became known as "Dr. Culver's Hospital."

Family members continued to reside in or near the Culver subdivision well into the 1950s, and their commitment to an integrated neighborhood seems to reflect that of Morton Culver himself, who owned forty acres of lots across six blocks, yet chose to locate his first black neighbors on property that adjoined his own residence.[13]

Thus it was that in July 1884 Homer and Nellie Wilson purchased three lots on the north side of Adams Avenue, midway between Greenwood and Vernon, from Morton Culver. According to Rose Dennis Booth, Glencoe's first historian, with this purchase the Wilsons became the first African American homeowners to settle in Glencoe. (The Wilsons' attorney in the transaction was Samuel R. Hurford, an early village trustee whose descendants, like those of his clients, remain active in Glencoe today.) Homer Wilson was born in Louisville, Kentucky, and lived for some years in Canada before returning to the United States, settling in Chicago about 1878. At first Wilson lived on Plymouth Court south of Polk Street, in what was then the heart of Chicago's African American community. When that block began to give way to the Dearborn Street Station—about the same time that he married Nellie Osborne—Wilson moved to 1605 South State Street. By 1884, when the Wilsons left Chicago for Glencoe, their daughter Sarah was three years old.[14]

Next to settle in Glencoe were the Rankins—Lucy, William and their young son, William Jr.—who moved from their home near Erie and Halsted Streets in Chicago to a house on Madison Avenue east of Vernon, in Christopher Uthe's subdivision. Other African Americans soon followed, so that within a short time about a dozen black families settled in the neighborhood. Most residents found work nearby in domestic service or in personal service jobs such as porter or driver, although a few continued to work in Chicago. One was Homer Wilson, who in 1893 was working as a porter for the Chicago, Rock Island and Pacific Railroad at the LaSalle Street Station, then as now on Van Buren at LaSalle. Another was John T. Walker, a resident of Washington Avenue in Glencoe, who at the same time was employed as janitor of the Calumet Building on LaSalle near Monroe, a significant work of architecture in its day and one of the first to establish South LaSalle Street as the center of Chicago's financial district.[15]

What sort of community was Glencoe in those days? In the 1880s, the population of three hundred was served by a "business district" consisting of a general store, a butcher shop, a shoe store, a depot and a post office. On one side of the railroad was a school, on the other side, a church. A few industrial operations remained from the Taylorsport days, such as a sawmill located on the site of today's Shelton Park near Old Green Bay Road and

Harbor Street. Village streets then were unlit, unpaved and often muddy, the sidewalks little more than wooden planks. There were no utility services, and water had to be drawn from wells about twenty feet deep; with no local sewage treatment, Lake Michigan was unfit for drinking or swimming.

Since the community lacked any municipal buildings, public meetings were held either at the Glencoe School or in the depot. No local high school yet existed, so the few children who continued after eighth grade commuted to Evanston, paying tuition. There were no recreational facilities or activities— public amusement was frowned upon in a village whose charter prohibited "tippling houses…gambling houses…and other disorderly establishments."

The surrounding area was often called the "Lake Shore"—the term "North Shore" had not yet come into use—and so the road from Chicago, more a series of loosely connected local streets, was known generally as Lake Road or Lake Shore Drive. Glencoe's segment then ended abruptly at Beach Road; soon it would be extended northward and the entire length renamed Sheridan Road. But there were no automobiles, and rough dirt roads that remained muddy long after wet weather ended were difficult even for horses to navigate. The community did enjoy frequent commuter service to Chicago: by the 1880s, there were ten trains per day running in each direction, and the fare was ten and a half cents per ride on a monthly ticket.[16]

No newspapers regularly served Glencoe, and so village government at first operated with only its own journal to record proceedings. In the early years, Glencoe's scattered houses were located in a settlement that was more rural than suburban. Most families kept cows, chickens and often horses in farm buildings that were reached by alleys extending behind many properties in the village; straying animals were a recurring local concern. Taxes on a large house in the 1880s were about twenty-five dollars per year.

The community's natural setting differed as well. Golf had not yet arrived, nor had the concept of land conservation, therefore around the borders of the village were located working farms and the Skokie Marsh in the place of today's country clubs and forest preserve. Within the settled areas, the remaining wooded sections enjoyed by early residents were giving way to open, cleared land. The lack of trees, combined with Glencoe's elevation of eighty to one hundred feet, enabled one resident to spot the flames of the Chicago Fire twenty-one miles away one October night in 1871 simply by gazing out the upstairs windows of his house. Yet many vacant lots remained, and in some neighborhoods entire blocks were left untouched well into the twentieth century. One commentator in 1900 went so far as to suggest that the Glencoe Farms development had been a mistake from the beginning:

Nature intended it the place for a cattle range and sticks to the original purpose with great persistency. Red clover and timothy are staple. Horseradish is a foreign innovation. Ragweed, Canada thistles, Russian milkweed and dandelions are interlopers. Dogs are indigenous, mosquitoes "to the manner born."[17]

Even finding one's way around was a different matter before the advent of house numbers. Because there were so few houses per block, the Homer Wilson home at 425 Adams was described then as "north side of Adams, first house west of Vernon," while Henry C. Wienecke would later open for business at the "west side of Vernon, fourth door south of Park," or simply "Vernon."

As Morton Culver and his neighbors were selling properties to African Americans, another developer was also beginning to attract black families to the neighborhood. His name was Ira Brown, and his property was located just south of Culver's on the blocks bounded by Jefferson, Vernon, Jackson and Grove.

Brown came to Chicago from rural Ohio in 1860 and developed a novel approach to residential real estate:

The plan adopted by Brown has been one which commended itself to the masses of home-seekers belonging to the middle and laboring classes. He was the originator of the monthly payment plan of selling lots, and not only has he disposed of hundreds of city lots and larger parcels of land in this way, but in many instances homes have been built by Mr. Brown and his associates and sold on the "easy payment" plan to industrious mechanics, tradesmen and laborers, who were thus enabled to become the owners of their own residences…In hundreds of cases little more has been required from such purchasers, to begin with, than evidence of their good intentions, and the man who could save five dollars a month out of his salary or wages was put in the way of acquiring a homestead. In this way Ira Brown has perhaps supplied a greater number of people with homes than any man now living in Chicago, and he has certainly contributed to the building up of a larger number of Chicago's suburbs than any other citizen of the city. In this respect his record has been a remarkable one, the public records of Cook County showing that through his various subdivisions of large bodies of land, he has added nearly fifteen thousand lots to the City of Chicago and its suburbs. Nor does this represent the total of his operations. In 1874, while spending the winter in California he became largely interested in San Diego lands, which he subdivided and sold ten years later.[18]

The Little Migration

Brown purchased acreage and divided each tract into unimproved residential lots with a frontage of just twenty-five feet, a few even narrower, at a price of fifteen dollars down and an easy payment plan in which he provided the financing. (An African American neighborhood today in LaGrange, eighteen miles west of Chicago, also stems from an early Ira Brown subdivision.) Brown promoted his properties partly through advertisements for "$100 lots," accompanied by his portrait, which he placed in newspapers and other publications. In a broadside from the 1880s, Brown described one of the communities in which he was active:

> GLENCOE *is situated on the Milwaukee Division of the North Western Rail Road, 14 miles from the City Limits, on the shore of* LAKE MICHIGAN, *which rises from 80 to 100 feet above a fine gravelly beach, giving a beautiful view of the Lake, where it is not an unusual thing to see fifty or more vessels and steamers at one time. It is needless to say that with such a situation drainage is natural and perfect. The best of wells, yielding an abundant supply of the purest of water, are reached at a depth of 18 to 24 feet. And another main feature about* GLENCOE *is, it is settled almost entirely by American people* [probably a suggestion that immigrants were not welcome] *and, to a great extent, Chicago business men. There are good Churches, School, and Stores, and a* CITY PARK OF SEVERAL ACRES, *with mammoth stairways leading down the rugged bluff to the beautiful waters of Lake Michigan, and the white, sandy beach below. It is hardly necessary to add that the Society is everything to be desired in a place with the qualifications of* GLENCOE. *Another important feature is the beautiful natural forest of maple, elm, oak, butternut, walnut and various other kinds of trees, which shade the entire village of Glencoe, having the appearance of one entire park, making a very picturesque appearance indeed. There is no suburb like Glencoe for beautiful residences, both costly and ornamental, and for health it cannot be surpassed. There has been of late over half a million spent in Glencoe in permanent improvements, and it is progressing with such great rapidity that those who purchase lots at the present prices must certainly double their money, and that very soon. Streets thrown up and in good condition, and sidewalks laid to the Depot.*[19]

Brown was aggressive. Just how he was able to do so is not clear, but in purchasing the Glencoe tract he seems to have acquired a bit more acreage than his predecessor had to convey, enabling him to squeeze in a few more lots at the east end of each block...if he could just push the street over a little. The resulting eastward displacement of Vernon Avenue at Jefferson has bedeviled drivers ever since.

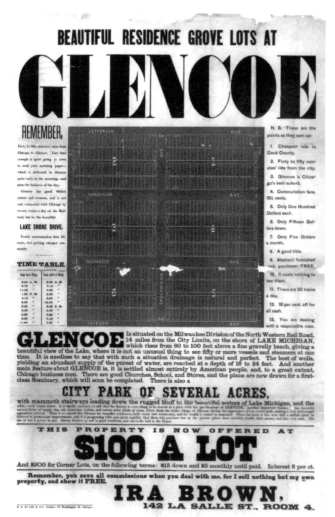

Ira Brown advertised extensively, here in a broadside that was probably posted in public places. *Glencoe Historical Society.*

As in Morton Culver's addition, and elsewhere in the neighborhood, African Americans purchased noncontiguous properties from Brown, creating a racial pattern similar to that found in many sections of Chicago at the time. By 1870, many of Chicago's blacks still resided in neighborhoods that were racially and ethnically mixed; few blocks anywhere in Chicago were entirely black. While that relative integration would soon give way to a dramatically different situation in Chicago, southwest Glencoe would for several generations continue to resemble city neighborhoods of earlier days.[20]

"Then Everyone Was Your Father, Everyone Your Mother"

William Ambrose was a black real estate agent who was active in Chicago during the 1880s and 1890s. Ambrose sold Ira Brown's Glencoe properties to African Americans through advertisements in *The Conservator*, and Ambrose himself owned residential property in southwest Glencoe.

Ambrose became known for his Sunday excursions to promote Glencoe to African American residents of the city. On one occasion, a reporter from the *Chicago Tribune* went along:

COLORED PICKNICKERS
An Enjoyable Day at Glencoe

Ambrose's Park, in the suburb Glencoe, was yesterday the scene of an old-fashioned barbecue and picnic, participated in by about 1800 colored people. A special train of eleven cars left the North Western depot at 11 o'clock, eight of the cars being managed by Western Gate Temple, No. 124, Knights of Labor...

At Glencoe the feasters were joined by colored companies from Lake View, Rogers Park, Lake Bluff, Evanston, Lake Forest, Highwood, Ravinia, and Waukegan. A procession headed by the Second Regiment Infantry Band of Chicago was formed, and after a half-mile march through leafy groves the picnickers were beside the tables which groaned under roast ox, cooked in halves and quartered afterward, roast lamb, roast turkeys, chickens, boiled vegetables, tea, coffee, fruits, and ice-cream. The principal business after the march was eating. Everybody ate, and everybody ate a great deal. Ten-year olds called for a third half of mince pie and ate it, and the women who laughed most seemed to be eating the most.

The diversions were dances in bowers prepared for the purpose, swinging, drinking pop, ginger-ale, lemonade and porter [weak malt liquor], *beer having been forbidden by the lodge, and in stretching and rolling upon the grass. Cupid was at work and came in for a fair share of the spoils…*

Once on the train home, the glad picnickers began to sing, "Shall we meet beyond the river?" and a song which ran something as follows:

In Jordan's lovely home we stand,
 And cast our gladdened eye
O'er Glencoe's fair and happy land—
 Where our possessions lie.

We'll rest in this beautiful land,
 Just along on Michigan's shore

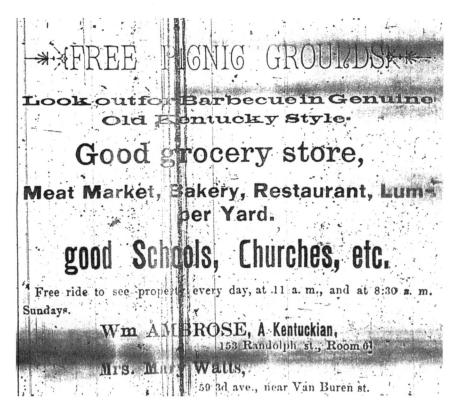

This ad appeared in *The Conservator*, Chicago's first African American newspaper, in 1886. *Chicago History Museum.*

Sing the song of Moses and the Lamb,
And dwell in Glencoe forevermore.

Filled with delight our raptured soul
Would here forever stay;
Michigan's waves around us roll,
But here we'll live and pray.[21]

In 1901, Sarah Wilson married William Rankin Jr. They first lived in the home of the senior Rankins on the South Side of Madison east of Vernon, later moving east down the block almost to Randolph and then around the corner to 427 Monroe. During that time, they became parents first of four daughters, Lucy, Mary Ellen, Sarah and Kernetha, and then of two sons, William III and Wilson.

Wilson Rankin

The late Wilson Rankin lived with his wife Effie on Jefferson Avenue near Green Bay Road.

I was born at 427 Monroe, about where the baseball diamond is today. Soon after that, we moved back to the house my Rankin grandparents had lived in on Madison, which was back-to-back with our house on Monroe. We stayed there until I was in high school, then we moved to my other grandparents' house on Adams, where my mother had come up as a child, and where she then lived for the rest of her life.

My grandfather, Homer Wilson, had moved to that house on Adams with his first wife, Nellie, who was my grandmother. But she soon died, and he married her sister Ellen. Grandpa had four children with Ellen and remained there all his life. The Culvers, who sold them the property, are gone, but their house still stands on Washington, while my relatives still live in the old homestead of my mother. It is back-to-back with the Culver house. When I was young, I remember the Culvers' daughter, Dr. Culver, walking around the neighborhood—she was a very tall woman who wore black, and I would see her go by as she was making house calls. Dr. Culver was one of just a few doctors in Glencoe then. Another was Dr. Fred Patton, who was our family doctor. His office was in

Wilson Rankin. *Effie Rankin.*

the building at Green Bay Road and Park Avenue, above Snyder's Drug Store.

Homer Wilson started the Wilson Laundry, which was sometimes called the Glencoe Laundry because it was the first commercial laundry in the village. He built a wing behind his house where he conducted the business. Customers would bring their laundry over in brown baskets, some walking, others on horseback. One of the

laundry's accounts was Fort Sheridan; when my grandfather would go up there to deliver officer uniforms, he'd always take a couple of kids along with him on his horse and wagon. It was a big time for the business around World War I, when the fort was very busy. The Wilson Laundry was well known in town—Glencoe used to blow a noon whistle that told everyone it was exactly twelve o'clock. Every day residents set their clocks, or told the time, by that whistle, and that whistle was blown at our laundry.

My other grandparents, the Rankins, moved to Glencoe a little after the Wilsons. My grandfather Rankin became active in town: he was a founder of the local Republican club and once ran for the Village Board. I remember visiting them in Chicago in their later years, when Grandfather worked for the Pennsylvania Railroad on the South Side. He had a wide, gray mustache, and he was a pretty strict grandpa.

My father, William Rankin Jr., was employed by the post office in Chicago for many years. Later, he went into the real estate business on his own. He had offices in Chicago and Glencoe and was active in promoting the south end. When the Italians began to live in the neighborhood, they would sometimes have difficulty bringing in relatives. My father used to go to Ellis Island and work out the problems so that the immigrants could join their families in Glencoe.

At that time there were several stores on the blocks around here. One was a grocery owned by Fletcher Pegues at the southeast corner of Madison and Randolph, which was one of several on Madison. Across Randolph and a little west on Madison, right next to where my parents lived before I was born, was the grocery that was later Stefani's, then Parenti's. But first the Craigs owned it. I remember when my mother would go in there to pay her bill—that meant a piece of candy or a piece of gum or a goody for me. You paid your bill every week, on Saturday, and Mr. Craig would give you a treat.

At the corner of Madison and Vernon, there was Sturlini & Manara, a grocery store that was later owned by Frank and Rose Ferraro. Frank and his family were one of those that my father met at Ellis Island; Frank's in-laws, the Battistas, lived here too. And just up Vernon you had Lenzini's, which was a small store where you could get penny candy. All the kids would stop there on their way from school.

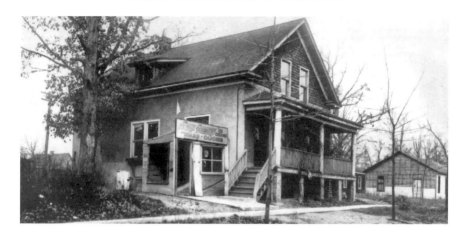

Callaway's was a popular after-school stop in the 1920s. *Glencoe Historical Society.*

These stores all delivered and so did the milkman, at first every day. In the winter he would come on a horse and sleigh, during the warm months on a horse and wagon. The bakery man came by horse and wagon, too. The iceman used to come every day as well, and you had a sign that you put in your window. You could get 25 pounds, 50, 75 or 100, according to which way you had that sign turned. And the ice cream we bought used to be packed in ice and then salted down to keep it good and cold.

Or if we wanted to go out for ice cream or soda pop there was Callaway's, on the east side of Vernon south of Jefferson. This was Mr. and Mrs. Callaway's house; the ice cream parlor was in their basement. It was quite a treat when you got to the bottom of those stairs because they had a complete fountain menu and those old soda parlor chairs with the wire backs. Ice cream cones cost a nickel, a double header for a dime. We also had a barbershop in the neighborhood, operated by Mr. Tyler in his house on Washington. At Jefferson and Randolph, Dave Medlock blocked and cleaned hats. And there was a music teacher too, Professor J. Howard Offutt. He was choir director at St. Paul AME Church, and he taught piano, violin and organ in his home, which was first a little west on Monroe and then on Jefferson.

We used to have big picnics and outings on summer holidays, and the highlight was always the barbecue. Across the street on Jefferson there used to be vacant lots, and the night before the holiday a bunch of the men in the neighborhood—Mr. Dean, Mr. Seabron, Mr. Cox, Uncle John—would get together there and dig

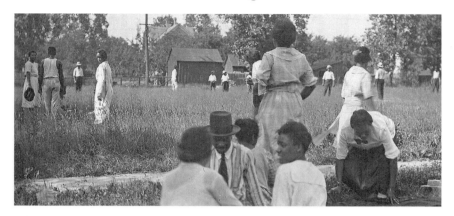

A picnic at Monroe Avenue, 1920s. *Glencoe Historical Society.*

a pit. Then they would stretch metal bedsprings across the pit, light a fire, season the meat and put it on. The men always brought something to drink, and we would sit up and keep the fire going. We brought along a dip that we made—no, I'm not going to tell you the recipe—and with a piece of cloth tied to the end of a long stick, we would baste the meat to keep it moist. Now we're not talking ribs—this was the whole hind quarter. This lasted all night, and the smell—oh boy, the aroma was over the whole village.

I went to Central School, then New Trier. At first, Central was the only public school in Glencoe. We walked to school, then walked home at noon for lunch and back at 1:30. The schools were mixed racially, and there was a heavier black population than there is now. We all got along fine. I still get together every fifth Friday with my classmates from the Central School class of 1931.

After Watts Park was built, a black baseball team started up that played twelve-inch ball with a glove. This was the Johnson Motors team, a member of the Park District league. Mr. Johnson had an auto repair shop in the garage space on Vernon north of Hazel. We had a strong infield—Wendell Carpenter at first base, "John K" Lipscomb at second, Roger Brown at shortstop and Leonard Brown at third; our outfielders included Bill Rankin, Curtis Brown, Lace Devilen, Jimmy Hubbard and Avon Diggs. Frank Sublett and I took turns pitching. And there was Julius "Duke" Miller, who lived on Jefferson. Pigeon-toed—he couldn't get from home plate to first base without tripping and falling—but he was a good catcher. Jim Lamkin was manager and really kept us together; Jimmy Foster

helped him. We had a pretty good team but no matter what, we always finished behind Glencoe News Agency. Nicholassi Nicolazzi was their star pitcher, they always had a strong team, and we couldn't ever beat them. We also played a black team from Lake Forest called the Gold Coasters. Once we beat them 5–0—behind my pitching. And they had home field advantage! Oh, were they mad.

My mother was everybody's friend, very active in the church, very active period. She could never turn anybody down, never see anybody put out. As long as we had the room, she would take them in. Most occasions were celebrated at her house on Adams, and we always had more than just family; with her, it was always, bring your friend too, because everybody brings somebody.

During World War II, when there was a lot of defense work, the women were working and my mother would take care of the children, even at her age. The mothers would drop them off at her house, and the kids would go off to school, while the parents would car pool and go to work in the defense plants, such as the Douglas plant where O'Hare Airport is now. My mother lived a very long life, and when the village celebrated its centennial in 1969, she was honored as Glencoe's oldest living resident.

In the old days, the Skokie Lagoons were a swamp. At certain times of year, it used to stink, while the peat moss burned for a long while every fall. I could jump on the ground, and you could be standing ten feet away and you would shake over there. Then Roosevelt created the Civilian Conservation Corps, and I joined and worked on the Skokie Lagoons project to get that all under control. There were ten companies at Camp Skokie Valley, each with 200 to 250 men. I stayed there about a year, then transferred to another CCC project in western Illinois near Mount Carroll. Later, I did construction work when we built the Naval Air Station at Glenview. We worked ten hours a day, seven days a week to get that ready, and we made big money from that.

I was drafted into the army at the time of World War II, and I told them I didn't want the army or the navy, but rather the marines. They looked at me as if I were crazy, but that's where I ended up. At that time, the services were segregated. The only base the marines had for blacks was at Camp Lejeune, near Jacksonville, North Carolina, where I did my boot training, and then I stayed there for the remainder of the war as a drill instructor.

The Little Migration

After the war, I came back to Glencoe and lived at home until I was married, then lived at several houses in the neighborhood. So all of my life has been within two or three blocks of here. My sister Sarah O'Kelley lived in Florida for a while, but my other sister, Kernetha Gregory, lived here all through her life. I used to be a volunteer fireman here in Glencoe along with my late brother Bill. For many years Bill worked at Wienecke's, and it was a long time tradition that every week Bob Morris, the village manager, Art and Evelyn Wienecke, Bill and I would get together. Sometimes we would have a treat if someone brought doughnuts, but that Saturday morning time with Evy and Art was a must.

The African Methodist Episcopal Church was founded as the Free African Society in 1787 by a group of black Methodists in Philadelphia; in 1816, it organized as America's first black religious denomination. While the AME name was chosen to indicate its origin among people of African descent, the Church has never had a policy of discrimination and has members of all races. Today, the AME Church is active in North and South America, the Caribbean, Great Britain and Africa, with eight thousand congregations and three million members worldwide. The Church also operates a number of educational institutions, including Wilberforce University in Ohio.[22]

The AME Church has deep roots in the Chicago area. Quinn Chapel, Chicago's first black congregation, was founded in the small hut of John and Rachel Day located on a lane that ran east of State Street between Lake and Randolph. As early as 1844, a group of seven—three men and four women—began holding prayer services at Day's home. Three years later, the group affiliated with the AME and first took the name Quinn Chapel after

The AME's anvil is meant to suggest the blacksmith shop in Philadelphia that Richard Allen, founder and first bishop of the AME Church, purchased in 1787 and converted into a house of worship. Four churches have been built on that site, which is today the oldest property in the United States under continuous African American ownership. *St. Paul AME Church.*

Bishop William P. Quinn, bishop of the AME diocese at the time. Quinn Chapel quickly became known as a point of entry and social service center for newcomers to Chicago. In 1853, the congregation dedicated a frame church on the site of today's Monadnock Building at Federal Street and Jackson Boulevard that served as a station on the Underground Railroad and a center of abolitionist sentiment in the city:

> *When the announcement was received that Lincoln had declared the Emancipation Proclamation should take effect on January 1, 1863, the colored people held a jubilee of a week's duration. The principal services were at Quinn's chapel on Jackson street, on which occasion sixteen colored men enlisted in the Union Army. On January 1, 1863, when the Proclamation went into effect, they likewise held continued and elaborate services to celebrate the important event.*[23]

The congregation occupied a series of churches over the next four decades until 1892, when it dedicated a new house of worship at Wabash Avenue and 24th Street that remains the home of Quinn Chapel today.

In the course of the late nineteenth century, the AME Church expanded its mission in the Chicago area as it continued to establish its own congregations and absorb previously organized groups. While many were located within the city limits, others extended the Church's reach well beyond. Nine miles north of Glencoe, for example, an AME congregation was organized in Lake Forest as early as 1866.[24]

The Glencoe African Methodist Episcopal Church, as it was first known, was formed in 1884 as a prayer group that met weekly at the home of Homer Wilson. Four years later the group affiliated with the AME Church and purchased property on the south side of Washington Avenue near Green Bay Road. According to the deed, Edward Hartwell sold the lot to the congregation for five dollars, "in trust" that the premises be maintained "as a place of Divine worship for the use of the ministry and membership of the African Methodist Episcopal Church in the United States of America, subject to the discipline, usage and ministerial appointments of said Church as from time to time authorized and declared by the General Conference and the Annual Conference, within whose bounds the premises are situate."[25]

The Wilson family tradition is that Homer Wilson financed the new church with a mortgage on his own property. When Wilson first purchased the three lots on Adams in 1884, he did take out an unusually large mortgage from Morton Culver, possibly with the understanding that in order to affiliate with an established denomination, his prayer group would soon need a home of

Deed of April 26, 1888, conveying the property at 336 Washington Avenue to the Glencoe African Methodist Episcopal Church. The deed was notarized by Morton Culver, who was likely involved in the transaction itself. *Cook County Recorder of Deeds.*

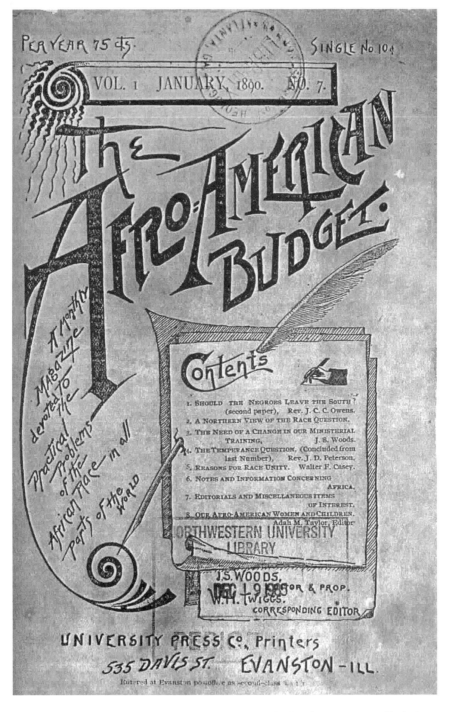

Reverend Jesse S. Woods published *The Afro-American Budget* for about ten years. *Charles Deering McCormick Library of Special Collections, Northwestern University Library.*

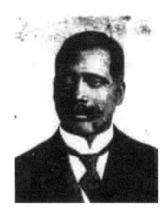

Reverend Woods, known as a builder of churches, founded AME congregations across Wisconsin and Illinois, including St. Paul AME in Glencoe. *Glencoe Historical Society.*

its own. In 1888, that arrangement with Culver apparently permitted the new group to acquire the Washington Avenue property and erect a house of worship at once. The new gray frame church with a pitched roof and modified steeple would serve the congregation for almost fifty years.[26]

The founding pastor of St. Paul AME Church was Reverend Jesse S. Woods. A native of Hannibal, Missouri, Woods was educated at Beloit College and Garrett Biblical Institute in Evanston. After his ordination in 1884, Reverend Woods ministered to AME congregations in Wisconsin and Illinois, where he was known for his talents as an organizer, writer and community activist as well as for his pastoral work. He was said to be a personal friend of Booker T. Washington and a compelling public speaker. In 1889, while living in Evanston, Reverend Woods founded *The Afro-American Budget*, "a monthly magazine devoted to the practical problems of the African Race in all parts of the world." Each issue featured articles by contributors such as Frederick Douglass; Dr. Daniel Hale Williams, a prominent black surgeon in Chicago; and Reverend Woods himself.[27]

It is the practice of the AME Church to reassign clergy every few years. As a result, many men and one woman have served the Glencoe congregation since its founding. St. Paul AME's current minister is Reverend Dr. John R. Halbert.

And from the congregation's early days, members of the Wilson and Rankin families have been part of its leadership.

Nancy King

Nancy King lives on Jefferson Avenue near Vernon Avenue, where she and her late husband Emmett raised their family. She is a great granddaughter of the Rankins and Wilsons, and a niece of Wilson Rankin.

In the early years, most of the members of the church lived in Glencoe. Many worked in domestic service and were unable to come to morning church, so the largest service was held on Sunday evening, when they had time off. But it was the fourth Sunday night of each month that was best known. That service was always devoted to music, by our choir and by guest artists. The church would be packed, because local residents wanted to hear them sing and because many others had heard them perform when they visited other churches on the North Shore. The choir then sang spirituals, they sang anthems, they sang hymns; gospel was not as big then as it has become today. Gospel is music that is written, while spirituals are handed down. They were the most requested then because they were so well known; Marian Anderson, for example, sang mainly spirituals.

Now, most members of St. Paul's come from a distance. That's because blacks weren't living in the suburbs then to the extent that they do now. Today, we have members who come from Wheeling, Glenview, Buffalo Grove and Libertyville, as

Nancy King. *Karen Ettelson.*

well as our traditional shoreline communities. We've never had a large membership, but now the congregation is more transient and mobile, because of job transfers—people come here for a few years and then they are transferred out. We still have the closeness of a small congregation, but it's not the same as when we were growing up. Then, everyone was your father, everyone your mother; now they're spread out, such as my own grandchildren, who come from Mundelein to church, then go back to Mundelein. When I was young, most of the kids you saw at church were the same ones you were playing with on the street or at the park.

There has always been a Sunday school at St. Paul's. My Grandmother Rankin taught there for many years and so in our family we didn't have a choice: you just went to Sunday school, which in our church is forever, since there is no confirmation or graduation. But it was also just a part of our social life, too, because we often had church picnics at places like Petrifying Springs in Wisconsin, and at groves along the Des Plaines River in the forest preserve.

My mother's name was Lucy, and she was the oldest of the Rankins. She was a gifted and talented person who for many years was organist at the church; she followed my great aunt, Helen Evins, in that position. Mother could sing and play, by reading and by ear. We had a choir at the church at that time that we say sang the church out of debt, because they performed at different churches on the North Shore and took contributions.

Mother wrote a family history in 1975. Her great-grandparents, Sarah and David Osborne, lived in Glencoe too, on Monroe east of Vernon. They were the parents of Nellie Wilson, and they came from Windsor, Ontario, to Chicago, then Evanston and on to Glencoe around the same time as the Wilsons. Mother remembered them both. She called her Great Grandfather Osborne "a sprightly man," and she recalled the "ash hoe" cakes—those were southern cornmeal pancakes—that her Great Grandma Osborne used to make. They called them that because the cakes used to be cooked on the blade of a hoe, before the fire or in the ashes so they wouldn't burn.

We believe that our family came from Guinea in West Africa, and that they came to Virginia aboard slave ships—we still teach the children a game that is said to have originated on slave ships. Later

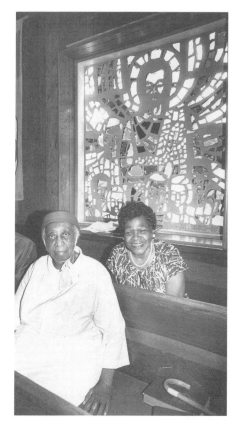

Left: Ruth Young (middle) and Alice Foster (right) in front of the window at St. Paul AME Church dedicated to Sarah Wilson Rankin, the mother of Wilson Rankin. *Glencoe Historical Society.*

Below: Choir at St. Paul AME Church, 1983. *Glencoe Historical Society.*

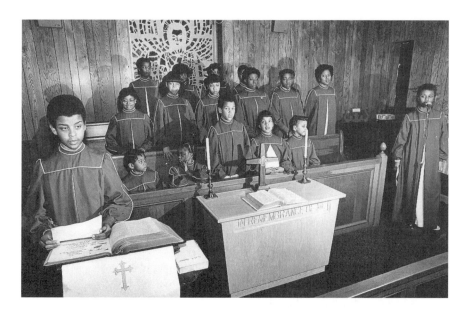

Mr. David Osborne (colored) died at his home on Monday morning. Mr. Osborne was seventy-six years old and has lived in Glencoe for twenty-six years. He was buried on Tuesday at Rose Hill.

Seven generations of David and Sarah Osborne's family have resided in Glencoe. Sheridan Road News-Letter, *November 27, 1910.*

they went to Canada, probably via the Underground Railroad, and then to Chicago. From there some went to Evanston while others settled here in Glencoe.

When I was born, we lived on Washington Avenue next to the church and after that on Adams. Then it was wartime. There was a shortage of housing, and homeowners were allowed to convert unattached garages into residential quarters. My parents, my brother and I moved into the garage of this house! It had a door with windows across the top, and we had flower boxes around the sides. Later we moved to my Grandmother Rankin's home on Adams.

On the blocks around here, it was blacks and Italians and other whites; everyone lived in the midst of the others, and we all consider each other old friends. I still see Mr. Funari, who had a landscaping business. He would jump out of his truck and yell at us in Italian, "Get out of the middle of the street," where we always played. His kids were playing with us too. When I went to work as a school administrator, people asked how I was able to get along with so many different people, and I told them that I had the advantage of growing up in an area where there were Jewish people, there were Catholics, all kinds of Protestants, Irish, German and so on. But most of my colleagues at work came from areas where it was all one group of people in their old Chicago neighborhoods. They came out of very isolated ethnic communities, and so when it came time to interact, they had a problem. But I didn't, because I was used to it.

I think the Glencoe schools gave me a strong educational background. I know how much of an impact my teachers had because I can still recall many of them. One was my sixth grade teacher, Miss Johnson, who later married my seventh grade teacher, Mr. La Cosse. When I was in her class, Miss Johnson often took me along when she went downtown for harpsichord lessons, and we would have a great time. Sometimes she took me to the Walnut Room, where at that time blacks were not welcome. But she was a feisty little thing; she would march in there and they couldn't tell her not to bring me too, so I would go in with her. Miss Johnson took me to the Art Institute and all kinds of places. She and her husband eventually moved into this neighborhood and kept in touch with me through my adult life.

Our family made festive occasions out of every holiday. We looked forward to Memorial Day, Fourth of July, Labor Day, all of them with big barbecues, picnics and children's activities—any day when the parents were off and we were off was a big holiday. It was always games and prizes in our family, and we always did skits. We did satires on each other; the kids enjoyed doing that. And we continue today at family reunions. In 1999, we had eighty-five people from all over the country for a weekend here in Glencoe. We held dinners, a worship service and a picnic at North School with prizes, T-shirts with the family tree and souvenir books to take home.

I was very athletic during my days at New Trier. I played on the field hockey team, and one year I was tennis champion in intramural girls' sports; the girls then didn't play other schools as the boys did. In fact, at that time at New Trier, girls were not even cheerleaders—that was for boys only. My adviser was Barbara Byrne, who was very special. She was a gym teacher, so we had a lot in common.

There were four black girls and one boy in our class of 539. So as far as dating was concerned, there wasn't a lot of opportunity for that. We dated boys from Evanston, but there was always the distance factor and that the kids often didn't have a car to come up here for a date. So I didn't do a lot of dating, but what I didn't have I didn't miss. We didn't let it get the best of us. Three of us girls were very good friends, so we did everything together. We had white friends too, but the parents of the three of us were also friends, and we all went to church together. We three are friends to this day.

I graduated from New Trier in 1952. A friend, Millard Dean, lived in Washington, and he told my mom about a college in Maryland

called Morgan State. He suggested a black college because it was a good school and because I had not had that much exposure to black people. I had a cousin who also lived in Washington and she, too, suggested Morgan State. So I applied and was accepted.

I loved it. It had a beautiful campus, and still looks good today. While it is fully integrated now, at that time the colleges in Maryland were all segregated. I really enjoyed it, and academically it wasn't that difficult for me. But during that time my mother became ill, so I returned home at the end of my freshman year and went to work.

When I first met Emmett King, he was trying out for the Chicago Cardinals. This was in 1954, when the team was training at Lake Forest College. A friend who lived nearby invited Emmett over to dinner, then called me to suggest that I go out with him. By that time, I had been fixed up with people who were as shy as I was and the dates were disasters because neither one of us would say anything. But Emmett and I had a great time, and in January 1955 we were married.

Emmett, who grew up in Hallettsville, Texas, had been playing for the Fifth Army football team in Europe when a scout for the Cardinals spotted him. So he came to Lake Forest, where he made the team and then played the entire 1954 season as starting fullback. That year, Emmett was one of four black players on the team, along with Jack Crittendon, Ollie Matson and Dick "Night Train" Lane. Emmett played that season and the beginning of the next, when he was injured. In those days, when you were injured, they just cut you, so that ended his career.

We first lived on the South Side, then in Evanston. My mother's sister, Maryellen, and her husband, Percy McCullough, had a catering business and on the weekends we worked for them. We saved enough to buy a house in Evanston, and we lived there until the owner of this house called to say that it was available. We moved here in 1965. Our son and daughter then went to South and Central Schools and on to New Trier, as did my mother before me. In fact, five generations of our family have gone through the Glencoe schools and New Trier.

My grandmother, Sarah Rankin, was very devoted to all the children in the family; she was at school all the time. No one could ever get away with anything because Grandma was at the school constantly, checking on them and talking with the teachers to see that they were behaving. She used to make apple butter that was so good, from the apples picked from the trees she planted on one of

In 1992, St. Paul AME Church dedicated a new house of worship designed by Andrews Associates, Chicago. *St. Paul AME Church.*

the lots next to her house. Grandma was always outside, walking into town each day. Once when she was ninety, she noticed a two-wheeler on the sidewalk, got on and took off down the street!

In 1886, Robert and Emma Chatman moved from Fifteenth Place near State Street in Chicago to a two-story frame house at the southeast corner of Madison and Vernon, where they opened a general store on the first floor and lived above. Along with the Wilson Laundry, theirs was one of the first establishments outside of the business district and probably served as a neighborhood center. When the old Glencoe School became overcrowded in 1889, the village turned to the Chatmans, who leased out the front room of their store building to house the primary grades—an early precursor of South School.[28]

Rose Dennis Booth was a Glencoe native and the descendant of pioneer white settlers. Mrs. Booth was a founder and first historian of the Glencoe Historical Society and took a lifelong interest in local history. Other than St. Paul AME Church, she is the sole source of written information on African American history in Glencoe. Mrs. Booth first wrote about black history in 1938, singling out several early families as "industrious and respected citizens," among them the Rankins, Wilsons, Chatmans and the family of Samuel H. Baker, a Pullman porter, who moved his young family from Evanston to Glencoe in 1895. The Bakers settled on Green Bay Road south of Adams, where Samuel Baker operated a garage for many years. He later became active in local real estate, trading and renting out neighborhood properties.

Skokie Country Club was established in 1897 on grounds that originally belonged to Michael Gormley. From its earliest days, the club employed

Described as a "landmark" by the *Glencoe News*, the Chatman store building at the southeast corner of Madison and Vernon lasted until 1930. *Glencoe Historical Society.*

R. H. CHATMAN,

Oils, Gasoline, Lamp Burners
and Wicks,
P. O. Box 92, Glencoe.

Left and below: The Chatman and McWill families were founders of St. Paul AME Church. *Highland Park Public Library.*

Mrs. G. McWIll...

GLENCOE, ILL.,

Treats the hair, complexion and feet. Her customers are among the leading women on the North Shore, whom she visits at their own homes. Her terms are very moderate. A postal sent to her at Glencoe will bring her.

African American neighbors, at times entire families. Three members of the extended Roberts family of Green Bay Road worked there, two of them as cooks, while at least five Rankins were employed in various capacities over the years. Two highly esteemed members of the club staff in the early days were Mary and Roger Williams, whose house and stable were located on Washington Avenue just east of the club grounds. Mary Williams prepared meals in season for members (dinner seventy-five cents, lunch fifty cents), while her husband operated an "omnibus," a twelve-seat version of a stagecoach, between the club grounds and the Glencoe station.[29]

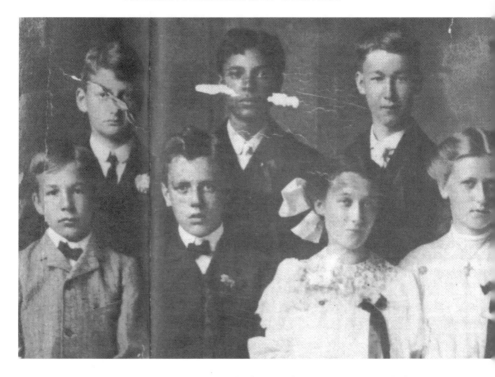

Henry Adams (top row, third from right) with the Glencoe School class of 1907. Isaiah Lindsay (top row, second from left) grew up on Monroe near Vernon. In the front row at far left is future poet and Librarian of Congress Archibald MacLeish, who grew up near Sheridan Road and Dell Place. At the time of Glencoe's centennial in 1969, MacLeish contributed his recollections to a village history: "My own class in Public School ended with twelve (mostly boys) and included, on wholly free and equal terms, three Negro boys,

Glencoe

William Cooper, the venerable color- ed man, who, in conjuction with horse and wagon, has been a familiar figure about the streets and station for two or three years past, died about one o'clock Thursday morning. Mr. Coop- er had been ailing sometime, and of late his condition had been regarded as serious. His death was probably due to pneumonia. Mr. Cooper was a slave in ante-war times. After the war his home was in Louisville, where his wife now lives. Mr. Cooper had been mak- ing his home here with his married son.

In the early years, news of the community was reported in columns written by Glencoe correspondents for area newspapers. This obituary appeared in March 1896 in the *North Shore News*, a weekly published in North Chicago. *Highland Park Public Library.*

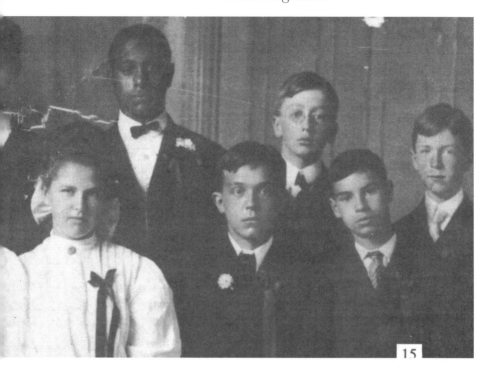

one of whom was said to have been brought home from Cuba after the Spanish War. We got along together—the boys of course—in the usual way: a kind of small-fry football and hapless baseball and numerous fights—usually back of the railroad tracks on the way home. And we liked where we were...hot or cold there was always the lake and the geese and the glimpse of the fox and the sound of surf when the wind was east and smelled of wood-smoke over the water." *Glencoe Historical Society.*

Henry Adams lived on Jackson west of Vernon; he grew up in Glencoe and remained in the village during his working life. For many years Adams worked as "right-hand man" to H.V. "Bert" Richardson, a son-in-law of Michael Gormley who operated a furniture moving and shipping concern in Glencoe. Henry Adams was well known for his very large size, considered especially suitable for moving the heavy furniture of his time.

Seemingly born to his work was George Waters, who provided ice to Glencoe households in the days before home refrigeration. Waters built an "ice house" behind his home where he made the ice in blocks, delivering it by horse and wagon to local residents and businesses. George and Henrietta Waters lived on Jefferson east of Vernon.[30]

Well before the Johnson Motors baseball team took the field, Glencoe was home to two earlier black clubs, now only barely remembered. Of the first, all that remains is a photo with the caption "Glencoe Wonders, 1901." No one today recalls much about that team or the next one, either, except that it was named the Glencoe Grays. This squad was no doubt inspired by the Homestead Grays, called "the greatest dynasty in the history of the Negro Leagues." Homestead is a city near Pittsburgh, and its club adopted a name that suggested the presumed color of steel. The Glencoe Grays played around 1920.[31]

Around the turn of the century, a growing population led to increased educational opportunities for local students. A new, larger Glencoe School was completed in 1898; New Trier High School opened its doors in 1901; and a year later some Glencoe families found themselves for the first time with a choice of elementary schools.

In 1897, Reverend Frederic J. Haarth was a young priest just four years out of the seminary when the Archbishop of Chicago directed him to establish a parish in Hubbard Woods to serve the Catholic families of Glencoe and Winnetka. Father Haarth would spend the remainder of his priesthood, forty-seven years, at Sacred Heart. He was known as a man of strong convictions,

Reverend Frederic J. Haarth with the Sacred Heart School class of 1908. The African American students are Mary Watts and her brother Thomas Watts Jr., who grew up at Adams and Randolph. *Sacred Heart Parish.*

sternly expressed, one of them being the absolute equality of every child at Sacred Heart School.

And from the time the school opened in 1902, its student body was surprisingly diverse. In addition to African Americans, there were children from Italian, Irish and Polish families, and even a few—"the Beinlich boys"—from German-speaking households who came to school straight from the farm.[32]

Burney Stewart is remembered as a tall, lanky man who worked for many years at the Evanston Post Office. A member of a family long associated with St. Paul AME Church and its choir, Burney Stewart contributed his own musical talents to an important community event the evening of February 12, 1909. This was Glencoe's commemoration of the Lincoln centennial, a service held before a standing-room crowd in the school auditorium. Village President James K. Calhoun, who presided, shared the stage with Glencoe's Civil War veterans. The evening's program featured reminiscences and stories about Lincoln, a recital of the Gettysburg Address and patriotic speeches; participants included the sixth, seventh and eighth grades, local clergy, the school principal and Burney Stewart, who provided a rendition of "The Battle Hymn of the Republic."[33]

The first Italians arrived in the south end around 1912. While many came directly from Italy, others settled first in Centerville, Iowa, a coal-mining town near the Missouri border where many of the immigrants made use of the mining skills they had brought with them from the old country. As the mines in Centerville played out, many families moved to Glencoe and nearby communities, where the men often found work in the construction trades or as landscapers and groundskeepers. A number of early families, including the Beneventis and the Chiappes, settled on Jefferson west of Vernon. Peter and Angeline Lenzini, who were also among the first Italians on the block, soon opened a small store at the northwest corner of Vernon and Jefferson next to their home. The store offered groceries and general merchandise but was best known for its penny candy. The Lenzinis operated the store for around fifteen years.[34]

At the same time, the black population in the neighborhood had increased sufficiently to support a second congregation. The Glencoe Baptist Church was organized in 1912 and soon erected a one-story frame building on the slight rise at the northeast corner of Madison and Vernon. Wilson Rankin recalled that on Sunday evenings, he could take in not only the music, but the service

Lenzini's, a popular spot for penny candy, 1920s. *Glencoe Historical Society.*

and sermons as well, from his family's front porch across Madison Avenue.

Reverend H.A. Trotter was the last of several ministers to serve the congregation, which disbanded in 1930. A number of members then planned to affiliate with a Baptist church in Evanston, but that was before Susie Miller and Sarah Rankin had a long talk with them. After giving the matter some thought, most changed their minds and joined St. Paul AME Church instead.[35]

Isaac Foster and his three brothers were brought to Glencoe in 1915 by their maternal grandmother, a Cherokee Indian who early in life had been kidnapped by bounty hunters and sold into slavery. Isaac Foster attended Central School and as a teenager worked in sanitation for the village. By the time he was in his mid-twenties, Foster had started his own business, Isaac Foster Disposal Service, which he operated for the next forty years from his home on Madison near Vernon. During the Depression, Foster took relatives into his home and gave them jobs on his crews, which served customers in Glencoe and nearby communities.[36]

Fletcher Pegues came to Glencoe from Memphis in 1918—via the Underground Railroad, he always insisted. Over the next fifty-five years, Pegues became a fixture in the community, at one time or another—and sometimes simultaneously—acting as grocer, banker, tax preparer, real estate promoter, building contractor, notary public and neighborhood organizer. Pegues was a longtime president of the board of St. Paul AME Church and represented the congregation at numerous church conferences. Fletcher Pegues was a well-known and colorful resident of the neighborhood who with his wife Annabelle lived on Randolph Street north of Jackson for many years.[37]

PART III

"No One Was Ever More Devoted to the Cause of Racial Justice"

In 1920, Morris Lewis, a lifelong resident of the South Side, purchased a house on Jefferson near Randolph in Glencoe that he, his wife Irene, their two sons and their daughters Dorothy and Caro used mainly during the summer months.

Morris Lewis was born in 1875, the son of Martin Van Buren Lewis, a messenger for the *Chicago Times*. Morris Lewis's first job in the 1890s was as typist-stenographer, then one of the few professions in which blacks and whites, both male and female, were welcome. After working in the office of a court reporter, Lewis spent four years as a stenographer for Luther Laflin Mills, a well-known white lawyer who was twice elected state's attorney of Cook County. Lewis then went to work for Ferdinand W. Peck, a leading citizen of Chicago and heir to one of the city's early real estate fortunes. Peck was a prominent developer himself whose projects included the Auditorium Building at Michigan and Congress, now the home of Roosevelt University; he was also instrumental in securing the 1893 World's Columbian Exposition for Chicago. When Peck was named commissioner general of the United States to the Paris Exposition of 1900, Lewis accompanied him to France. Morris Lewis served as executive assistant to Ferdinand Peck and the Peck estate for twenty-four years.

Lewis was an early executive director of the Wabash Avenue YMCA, for many years a center of black life in Chicago, and during the 1920s he worked as head of circulation for the *Chicago Defender* and executive director of the Chicago NAACP. Long active in politics, Lewis devoted a good deal of attention over the years to the Second Ward while also taking an active role at Quinn Chapel. In 1929, Lewis went to work as secretary, or administrative assistant, to newly elected U.S. representative Oscar DePriest of the South Side, remaining in that position during DePriest's three terms in Washington.

DE PRIEST TO FORCE VOTE ON COLOR LINE

Will Demand Serving of Negroes in Capitol Grill—His Secretary Was Barred.

WASHINGTON, Jan. 23 (AP).—A decision as to whether Negroes shall be allowed to eat with whites in the public restaurant operated in the Capitol will be demanded of the House tomorrow.

Representative Oscar De Priest, Republican of Illinois, the only Negro member, said tonight he would bring up the question. Employes of the restaurant had refused to serve his secretary, Morris Lewis, and another Negro in the grill.

Chairman Warren, Democrat of North Carolina, of the Accounts Committee, which has charge of the restaurant, said tonight in a brief formal statement:

"In refusing to serve two Negroes today in the House restaurant, Manager P. H. Johnson of the restaurant was acting upon my orders and instructions. The restaurant has been operated by the Committee of Accounts since 1921.

"It has never served Negro employes or visitors, nor will it so long as I have anything to do with it."

The manager stated that when the Negroes demanded to know who was responsible for the order not to serve them, he told them the House Accounts Committee.

"They said they were American citizens and refused to be insulted like that," Mr. Johnson added.

They went into Mr. Warren's office, but he was in the House chamber. They then complained to Representative De Priest.

The Negro Representative said he would force a vote on a privileged resolution. Explaining that he often had Negro guests in the restaurant, he said he could see no objection to Negroes eating in the public section, although he could see how the members' section could be reserved.

"I am going to see to it that Negroes are going to eat in the grill or we can close it," he added.

Representative Warren said that as a member of Congress, De Priest had a right to eat there, adding "if we let one Negro employe eat in the restaurant, we'll have to let all of them. It always has been the rule to feed only white people in the restaurant."

The *New York Times,* January 24, 1934. *Glencoe Public Library.*

Upon his election, Oscar DePriest became the first African American to serve in the U.S. House of Representatives since 1901 and the first ever from a northern state; even before taking office, DePriest became a renowned figure as African Americans across the nation quickly came to think of him as "their" Congressman. Earlier, DePriest served on the Cook County Board, and in 1915 he was elected Chicago's first black alderman. Morris Lewis and his family were very sociable, and over the years their Glencoe home became an informal gathering place on summer weekends as friends from Chicago, including DePriest, often stopped by.

Morris Lewis was wise in the ways of politics, in Chicago and in Washington, but to family members he was a soft-spoken, gentle man who always had time for his grandchildren. They recall summer meals on the porch, sunning on the roof and picnics at the beach, their grandfather always a kindly presence.[38]

The Little Migration

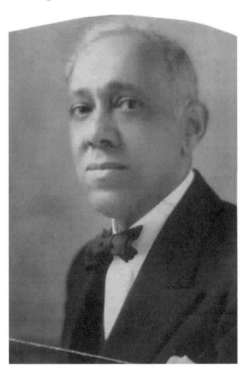

Morris Lewis. *Beverly Carr.*

One of Samuel H. Baker's sons, Percy, remained in Glencoe throughout his life, residing with his wife Izma on Randolph near Jackson for over fifty years. In 1973, the *Glencoe News* looked back on Percy Baker's career:

> *Louis Baker retired more than two years ago from the Illinois Department of Agriculture after 32 years as a bee inspector.*
>
> *At the time of his retirement in 1970, the* American Bee Journal *stated that Baker was the only black apiary inspector in America.*
>
> *Called Percy by his friends, Baker expresses a deep affection for bees.*
>
> *"The little fellows are one hundred times more important to man for their pollinating services than the honey they produce," he says. Some beekeepers raise bees solely to rent out in the spring to farmers and fruit growers.*
>
> *He emphasizes that you couldn't buy a decent steak if it weren't for bees. Clover, a steer's meal, relies entirely on bees for cross-pollination as does alfalfa and all other members of the grass family.*
>
> *"Honey made from clover is the finest tasting you will find," he says. "Nectar of the blossom determines a honey's taste. A full spectrum of flavor may be found running from strong black honey derived from buckwheat blossoms to the pale, sugary kind made from plum blossoms."*[39]

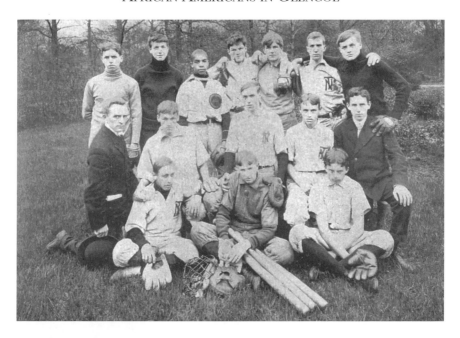

Above: Percy Baker and his sisters were early students at New Trier High School. He is pictured here (top row, third from left) with his fellow members of the 1905 New Trier baseball team. *New Trier Township High School Archives.*

Left: Percy Baker. *Glencoe Historical Society.*

Upon his retirement, Percy Baker served as president of the Glencoe Rotary Club, and he turned a vocation into a hobby: neighbors still recall the buzzing of the bees in the Baker backyard.

Around the same time, Tom Brown Jr., a resident of Jefferson Avenue and a talented drummer, formed an all-black jazz band that he named the Society

Syncopators. With Brown as its leader, the Syncopators played at parties along the North Shore during the 1920s, including several dates at Skokie Country Club.[40]

Watts Park was created in 1930 despite vocal opposition from African Americans, who objected to the displacement of black families living on the site of the park, as well as to the process by which many properties in the neighborhood had already changed hands. That process had actually begun about ten years earlier.

By the turn of the century, Glencoe was evolving from the isolated, semirural outpost of earlier times to a residential community facing stiff competition from other North Shore suburbs. Prospective homeowners found an attractive village whose schools were highly regarded yet frequently overcrowded; other public services, including parks, were likewise inadequate by professional standards. The community had responded to some degree: a public library was opened in 1910, a park district was created in 1912 and a "village manager" system of government was adopted in 1914. Yet Glencoe found itself unable to keep up with a quickly growing and increasingly demanding population.

Those who worried about the lack of adequate space for public use in the village could turn to a growing professional authority in the field of municipal and regional planning. The *Plan of Chicago*, by Daniel H. Burnham and Edward H. Bennett, was published to great acclaim in 1909 and quickly became influential not only in the Chicago area, but also across the nation and beyond. The *Plan* was a comprehensive proposal in which Burnham and Bennett pointed out the advantages of planning not only for the central city, but for outlying communities as well. They proposed that each Chicago suburb adopt guidelines in which "spaces should be marked out for public schools, and each school should have about it ample playgrounds, so that all during the year the school premises shall be the children's center...Next to the school, the public library should have place; and here again the landscape setting should be generous and the situation commanding."[41]

Many Chicago residents who moved to the North Shore in the early twentieth century were attracted by the country clubs of the area, themselves prominent examples of open space. In southwest Glencoe, Skokie Country Club members who had built summer cottages near the club grounds began to turn them into year-round residences. New houses nearby were often erected on two or more of the earlier, smaller lots.

By that time, however, other properties in the neighborhood, some of them owned by blacks, had deteriorated. Many parcels remained vacant, but

given no maintenance or improvements, even sidewalks, they had become overgrown to the street. Those dwellings that did exist were built haphazardly, many of them lacking utilities. Building and fire violations were common, absentee ownership and tax delinquency ongoing problems. The authors of the *Plan of Chicago* might have had Ira Brown's subdivision in mind when they wrote:

> *Too often…the suburb is laid out by the speculative real estate agent who exerts himself to make every dollar invested turn into as many dollars as possible. Human ingenuity contrives to crowd the maximum number of building lots into the minimum space; if native trees exist they are ruthlessly sacrificed. Then the speculative builder takes matters in hand and in a few months the narrow, grassless streets are lined with rows of cheaply constructed dwellings…In ten years or less the dwellings are dropping to pieces.*[42]

A group of white Glencoe residents, including several experienced in real estate, decided to take it upon themselves to eliminate, or at least reduce, the number of such properties. In 1919, two years before Glencoe adopted zoning controls and a decade before those controls began to take serious effect, they organized an investor group called the Glencoe Homes Association. With funds raised from its members, the association purchased residential lots across the southwest part of the village and resold them, with zoning-like restrictions, to local homebuilders, using the profits to purchase additional properties. Over the next ten years, the association bought, resold and sometimes reconfigured about 250 parcels on the forty blocks bounded by South Avenue, Green Bay Road, Drexel Avenue and Grove Street; the group was particularly active along Jackson Avenue and in the Ira Brown subdivision. As part of its plan, Glencoe Homes sold properties at cost to the Glencoe Board of Education for South School, which opened in 1926, and to the Glencoe Park District for a park to be built west of the school.

In October 1928, the need for the park, as well as the motives of those behind it, briefly became matters of open controversy when two hundred property owners living in the neighborhood, probably encouraged by the Glencoe Homes group, signed a petition that they presented to park commissioners. The petitioners, not one of whom was identified by name by the Park Board or in the *Glencoe News*, demanded that the Park District condemn eighty-six parcels along Randolph, Monroe, Vernon and three other streets, and they committed themselves to a twenty-year assessment that would finance the construction of a park on the site.

The Glencoe Homes Association purchased many properties such as this, on Monroe east of Greenwood. *Glencoe Historical Society.*

Jackson Avenue, east of Greenwood. *Glencoe Historical Society.*

Of the 86 parcels, 64 were vacant, some already owned by Glencoe Homes. The resistance came from the remaining 22 owner/residents—half of them black—who refused all offers. Despite heated arguments at a lengthy, contentious public hearing—described by the *Glencoe News* in as few words as possible—the Park District proceeded to take their property by instituting

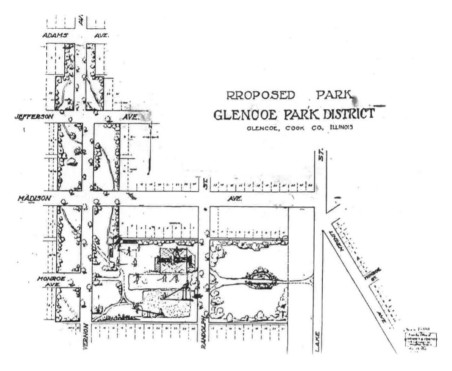

The overall plan of the sixteen-acre Watts Park, including its stepped northern entrance, is probably the work of landscape architect Jens Jensen, who worked as a consultant to the Park District during the planning process. Jensen selected the park's original native plantings along with a protégé, Robert Everly, who in 1930 became Glencoe's first superintendent of parks. *Glencoe Public Library.*

condemnation proceedings and creating the "special assessment" district demanded by the petitioners. Under Illinois law, when an owner objects to the amount offered as compensation for the property to be taken, a judge or jury is called upon to review the amount proposed and adjust it in light of evidence introduced at public hearings. In the case of Monroe-Vernon Park, as Watts Park was first called, most of the 22 property owners who contested the original award did receive an increased amount.

It is difficult to gauge community opinion at the time, since the *Glencoe News* acknowledged the matter only in the course of reporting on the public hearing, and no residents on any side ever wrote the paper to express their views. The Park Board itself never commented publicly on the issue, but it may have revealed its sensitivity a few years later as the effects of the Depression became more pronounced in the community. For it was the Park District that took the lead among local governments in securing scarce public funds for employing Glencoe residents—at one point nearly

one hundred—who were on relief. Many of those residents, both black and white, lived in the south end.[43]

At one o'clock on the morning of September 17, 1930, St. Paul AME Church on Washington Avenue was destroyed by fire. High school senior Wendell Carpenter, who lived on Adams Avenue just behind the church, noticed it at once. Carpenter recalled that he had just returned home when he looked out his bedroom window to see flames coming from the church. He ran to tell his mother, who was first to call the fire department.

Two young Glencoe men, both white, were soon arrested and indicted for the crime of arson. As time passed, neighborhood residents who traveled to the Cook County Criminal Court House at 26th and California—a long journey at that time—became angered by repeated delays in the disposition of the two cases. In fact, there were 35 continuances, the consequence of protracted plea negotiations that at various times involved each of the defendants; their attorneys; the state's attorney; the state fire marshal, who was an important prosecution witness; and directors of the church. One of the defendants chose to go to trial and was acquitted, apparently because the evidence showed him to be so heavily intoxicated that night that not only was he unable to form the requisite intent needed to commit the crime of arson under Illinois law but also that he could barely recall the incident at all.

The second defendant's case proceeded differently. Because the evidence showed that he was the leader of the two, yet also highly intoxicated the night of the crime, the state and the defendant's attorneys reached an agreement on punishment for him of a brief detention in the county jail followed by probation. Yet when it came to sentencing, the trial judge elected not to accept the plea agreement and instead ordered the defendant to state prison, precisely the outcome that the parties sought to avoid. Believing that the judge had not honored the plea agreement, the defendant sought to withdraw his guilty plea. The motion was denied, and eventually, in 1934, the Illinois Supreme Court overturned the judgment of the trial court and ordered the defendant released.

The Supreme Court determined that the defendant could not have sufficiently understood either the options available to him when he pleaded guilty or the severity of the sentence he would receive if he did so. The court also suggested that the state's attorney may have exerted undue influence over him in his decision to plead guilty.

The court found serious problems elsewhere in the case as well, including flaws in the indictment under which the defendants had been brought

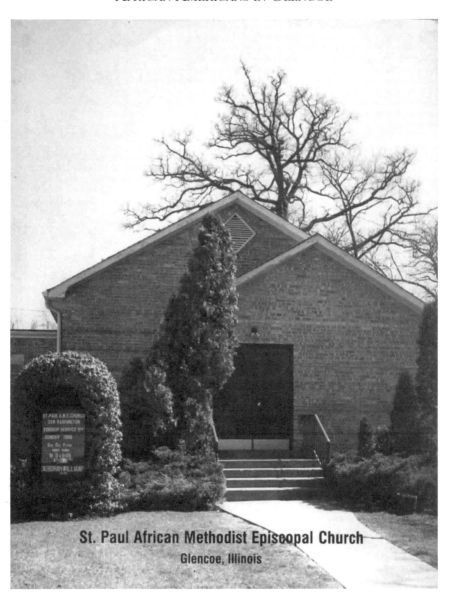

St. Paul African Methodist Episcopal Church
Glencoe, Illinois

The 1931 church was designed by Charles S. Duke, one of the first African American architects and engineers in Chicago. Throughout a forty-year career, Duke, who was licensed in both professions, participated in the design of a wide variety of projects and left a distinguished record of service to his profession and to the public. In 1934, Duke drafted an early plan for the Ida B. Wells Homes at 37th and King Drive, the first public housing project in Chicago for African Americans. After graduating from Phillips Exeter Academy in New Hampshire, Duke went on to Harvard, where he earned a bachelor's degree in 1904. He completed his education at the University of Wisconsin, where he received a master's degree in civil engineering. *Glencoe Historical Society.*

to trial. The first defect was that they had been charged with "arson" while under Illinois law, "arson" was limited to the burning of residential buildings. The court held that the defendants should have been indicted under another provision of the criminal code that applied to the burning of church buildings, a crime that was not considered "arson."

Even more significant to the Supreme Court was the fact that the name and legal status of St. Paul AME Church—the injured party in this case—were also misstated in the indictment. The justices found these defects alone so incurable as to taint the entire case and preclude any further proceedings. Thus the pursuit of a just resolution to a case that took over three years to prosecute and appeal, a case in which the facts of the crime were never in dispute, ended in a frustration that was shared by all parties.[44]

In 1931, St. Paul AME Church dedicated a new brick church to replace the original frame structure.[45]

Albon L. Foster came to Chicago in 1925 to join the Chicago Urban League as its second executive director, a position that Foster would hold for twenty-one years. The Chicago Urban League was founded in 1916 partly in response to the growing number of blacks from the rural South who were migrating to Chicago, many of them unskilled and overwhelmed by urban life. During Foster's years at the Urban League, its staff included professionals in the areas of job training and placement and a research department that collected and analyzed information on black life in Chicago. Others trained black social workers, helped coordinate social services provided to African Americans and assisted neighborhood organizations.

Foster, who was educated at Wilberforce and Ohio State Universities, came to Chicago at a time when there were few black professional leaders. As African Americans settled in Chicago in increasingly large numbers, the Urban League under Foster assumed an important role in the difficult adjustments many migrants faced to a bewildering urban environment, a plight only made worse by the effects of the Depression:

IF YOU ARE A STRANGER IN THE CITY

If you want a job. If you want a place to live. If you are having trouble with your employer. If you want information or advice of any kind,

CALL UPON

The Chicago League on Urban Conditions Among Negroes
3303 South State Street

Telephone Douglas 2455 T. ARNOLD HILL, Executive Secretary
No Charges—No Fees. We Want to Help YOU

From its earliest days, the Chicago Urban League reached out to newcomers. This ad appeared in 1917. *Chicago Public Library.*

In one section of the Second Ward over 85 per cent of the persons…who had been gainfully employed in 1930 were unemployed a year later. The relief agencies were not properly equipped or properly financed to meet the situation. Many colored persons faced the prospect of a cold winter without food, shelter and proper clothing. Bank failures in the Negro Community were more complete and devastating than in other sections of the city and this meant that some of the middle-class Negroes who had raised their economic status at great personal sacrifice also became poverty-stricken. It was estimated that the Negroes [who comprised 7 percent of Chicago's population] *constituted one-fourth of all the relief cases in the city. When the relief agencies ceased to pay rents there were many evictions, and when the funds of the United Charities ran low the allowances for food were drastically cut.*[46]

Nor was the Urban League itself immune from the times. As conditions forced one staff member after another to depart, it was finally left to Foster and an assistant to carry on. They did so on their own for two years, without pay, in order to keep the organization afloat.

Foster also played an active role as a civic leader, negotiator on a wide variety of issues and controversies and spokesman to the broader community, frequently taking on difficult assignments.

For example, one day in August 1931, public officials evicted an elderly black woman from an apartment near 50th and Dearborn on the South Side. A crowd gathered, police were called and a riot erupted, leaving three dead and many injured. At a moment of citywide concern that further violence might follow, Foster returned from vacation to help take charge. He did so successfully, winning a moratorium on evictions and commitments of additional relief from private agencies and from the City of Chicago, which had to borrow the $50,000 it pledged to Foster.

Long concerned over poor housing on the South Side, Foster organized a study group in 1933 to examine the problem and prepare a plan to address it. The study group evolved into a larger committee of prominent black leaders called the Citizens' Housing Committee. In 1934, on its own initiative, the committee submitted a comprehensive proposal for public housing to federal housing officials that included an ambitious site plan prepared by Charles S. Duke for a one-hundred-acre site at King Drive and Pershing Road. After many delays and revisions, the Ida B. Wells Homes opened in 1941 as the first public housing project in Chicago for African Americans.

A.L. Foster left the Chicago Urban League in 1946 after serving under its first two African American presidents, Dr. M.O. Bousfield and Earl B. Dickerson. Foster later worked for private industry before taking charge of

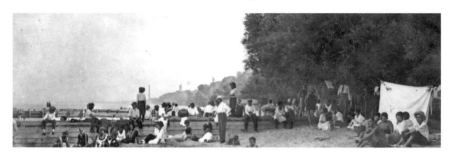

Harbor Street beach, 1920s. *Glencoe Historical Society.*

the Cosmopolitan Chamber of Commerce, a business organization he had helped establish in 1935.[47]

In 1940, Foster and his family moved to Glencoe. When he found that blacks were reluctant to use the Glencoe beach at Park Avenue, congregating instead at the foot of Harbor Street, Foster decided to make himself a test case. In June 1941, he applied to the Glencoe Park District for an annual beach pass. When three weeks passed without a reply, Foster took the matter to Cook County Circuit Court. Represented by attorneys Nelson M. Willis and Earl B. Dickerson, Foster demanded that a judge order the Park District to issue him a pass. Discussions continued over the summer, resulting in the issuance of a beach pass to Foster late in the season. The case was then dismissed.

The following summer, Foster went to U.S. District Court, seeking perpetual relief. In July 1942, Judge William H. Holly issued an order permanently enjoining the Park District from denying beach passes to A.L. Foster, his wife Mildred and their two sons. Before long, most blacks abandoned Harbor Street in favor of Park Avenue. (At the conclusion of the litigation, Foster claimed that he was acting on behalf of the "50" black families then residing in the village. That is the only published figure ever found for the African American population of southwest Glencoe.)

As prominent citizens of Chicago, A.L. Foster and his wife came to know many important public figures, frequently entertaining them at their residence in the city and continuing the practice after their move to Glencoe. W.E.B. Du Bois was one of many distinguished guests who visited the Fosters over the years at their home on Jefferson near Randolph.[48]

At the time of Foster's death in 1968, the *Chicago Defender* remembered him in an editorial:

> *No one was ever more devoted to the cause of racial justice than A.L. Foster.*
> *Under his leadership, the Urban League, which he headed for more than*

65

A.L. Foster. *Leonard Foster.*

two decades, attained goals that were thought to be beyond accomplishment considering the crucial obstacles he had to surmount…

Foster fought the battle single handedly for a black community that was so petrified under relentless impact of race prejudice that it became apathetic to the course of its own destiny. By dint of personal steadfastness, by constantly exposing himself to the dangers of police brutality, by challenging white encroachment on the rights of Negro citizens, Foster succeeded in arousing a representative segment of the Negro community to its moral responsibility.

He did more than that. He gained the confidence of the white community to such a degree as to cause some of its influential members to bring about a better and more productive dialog in the relationship between the two races. He had the gift of positive thinking and a persuasive logic with which to sustain his arguments.

Yet, Foster was uncompromising. He never retreated, never gave ground before the enemy's onslaught. The bigger the battle, the more determined he was to see it through. He had both imagination and stamina—qualities which he later transferred to the Cosmopolitan Chamber of Commerce as its leading light.

In death, the entire city of Chicago has lost one of its truly dedicated citizens, a dedication that was marked at once by humility and dignity.[49]

"Why Don't They Let Us Fly Planes and Run Ships…"

–Richard Wright, *Native Son*, 1940[50]

The African American pilots known as the Tuskegee Airmen, who flew bombing raids all over Europe, have been the subjects of increasing attention in recent years, such as this account in *The Tuskegee Airmen: The Men Who Changed a Nation*:

> *During a training mission of May 28, 1944, the engine in the plane of Lt. Roger B. Brown of Glencoe, Illinois conked out while he was flying 2,000 feet above water. After unsuccessfully attempting to start his engine, Brown found himself only 800 feet above the water and falling too fast to jump with his parachute. He jettisoned the doors of his P-39 Airocobra, unfastened everything he could, cut off his switches, placed his hands over his gunsight, and held his plane off the water until his air speed was less than 120 miles per hour. When his ship hit the water, he abandoned it in less than three seconds. Yet, despite his swiftness in getting out, the tail of his fast sinking plane struck him.*
>
> *Lt. Brown was rescued by a British vessel shortly thereafter. For his accomplishment, he was officially commended for being the first pilot in the United States Air Force known to have successfully crash landed a P-39 Airocobra at sea.[51]*

Roger Brown grew up on Madison near Grove, and then on Jefferson near Randolph, the youngest of four sons. His grandparents, Nellie and Marshall Craig, were the first proprietors of the store on Madison that later became known as Parenti's. Roger went through the Glencoe schools and graduated from New Trier High School in 1935. There was music in the family: one of Roger's brothers was Tom Brown Jr., the jazz musician, while Roger himself sang in the choir at St. Paul AME Church from an early age.

P-39 Airocobras in Italy, 1944. *Tuskegee Airmen, Inc.*

After high school, Brown worked as a chauffeur in Glencoe and later at the Buick defense plant in Melrose Park. In 1937, he married Mabel O'Kelley, whose relatives live in Glencoe today.

Brown enlisted in the army not long after Pearl Harbor. In February 1943, he entered the army's first program to train African American pilots for combat service and aerial escort over Europe. Brown completed seven months of primary pilot training at Tuskegee, Alabama, in November of that year, at which time he was commissioned a second lieutenant. From there, he went on to Selfridge Air Force Base near Detroit for advanced instruction in aerial combat.[52]

Perhaps the most glamorous job in the military in 1941 was that of fighter pilot, who had to use all the skill and daring at his command in managing to fly, navigate and man the guns all at the same time. The job of the fighter pilot was to attack enemy fighters who threatened American bombing missions, and while many pilots worked in groups, sometimes they were called upon to engage in single combat with the enemy. Cadets in the Tuskegee program such as Roger Brown understood that they were being given an unprecedented—and highly visible—opportunity to prove that they could handle such challenging assignments.[53]

Tuskegee itself was a town of shaded residential streets radiating from a courthouse square and Confederate monument, much like the fictional Maycomb in *To Kill a Mockingbird*. Recruits were greeted by Jim Crow laws that mandated the segregation of the races in every aspect of daily life. Family housing was difficult if not impossible to find, while schools and all other public and private facilities were so strictly segregated that cadets and their families often found it more difficult to adjust to the harsh environment of the rural South than to the rigors of military training.[54]

As for the army, its leadership viewed the Tuskegee Airmen with a skepticism, even hostility, which dated back to the formation of the Army Air Corps, predecessor of today's United States Air Force. From the earliest days the Army Air Corps insisted that African Americans were, and always would be, incapable of flying airplanes, and that even if somehow they were qualified, whites would never agree to serve along with them.

In March 1944, Lieutenant Roger B. Brown joined the Fifteenth Air Force's all-black 332nd Fighter Group in Italy, then under the command of the legendary Colonel Benjamin O. Davis Jr. Colonel Davis, the son of the army's only African American general, was himself a 1936 graduate of West Point who eventually rose to the rank of three-star general. In 1998, General Davis made news well into retirement when President Clinton awarded him a fourth star in a ceremony attended by a number of Tuskegee Airmen.[55]

In June 1944, not long after Lieutenant Roger Brown arrived, the 332nd Fighter Group became a long-range heavy bomber escort unit. From then until April 1945, the 332nd completed nearly every one of its bomber escort missions—two hundred of them, over most of central and southern Europe—without a loss of a single bomber to enemy aircraft. This remarkable achievement prompted frequent expressions of appreciation from bomber pilots and crews, who depended on fighter escorts for protection during bombing raids, as well as on the way to and from their targets.[56]

Lieutenant Brown was assigned to the 332nd Fighter Group's 100th Fighter Squadron, whose commanding officer was Captain Robert B. Tresville, the seventh African American to graduate from West Point. Captain Tresville was widely admired for his courage as a pilot, as well for his strong personal skills, and was considered among the most promising of the Tuskegee Airmen leadership. Under Captain Tresville's command, the 100th Squadron prepared for combat every day as it carried out harbor protection at Naples, point-to-point escorts, submarine hunts and rescues at sea, while frequently encountering, and giving chase to, enemy aircraft.[57]

Lieutenant Roger B. Brown died on June 14, 1944, when his plane crashed during a training flight. The crash took place in the Apennine Mountains

not far from Ramitelli Airfield, where the 100th Squadron was based; the official cause was given as "engine trouble." The following day, Lieutenant William T. Mattison provided this account:

> *On 14 June 1944 at 1620 hours, I was leading a two-ship flight of P-47's ["Thunderbolts"] on a training flight. Lt. Brown was flying my wing and I noticed him dropping back. At the same time I throttled back and I noticed his ship was smoking and increasing to a dense black smoke. He then was losing altitude. I told him to bail out, but I did not see him jump due to scattered clouds and haze. I saw his plane hit the ground and burst into flame. I circled three times trying to give the May Day and transmitting for a fix…*
> *My flight was above the clouds the entire trip until Lt. Brown went down. I told him to jump when he was about 5000 feet above the mountains; my altimeter was reading 9000 feet. We both went down through the clouds and I was only able to see the plane crash and burst into flame. I had very poor radio contact and was unable to understand any transmission.*

Captain Tresville added this:

> *At approximately 1830 hours, 14 June 1944, a searching party consisting of two single engine aircraft went to what was thought to be the place where aircraft piloted by 2nd Lt. ROGER B. BROWN, crashed. The visibility at this time was very good. Spots were seen where grass had evidently been burned, but there was nothing to indicate a plane had burned.*
> *The search lasted for about two hours but no evidence of missing pilot or aircraft was discovered.[58]*

On June 22, just seven days after submitting this report, Captain Tresville was himself killed when his plane crashed at sea.[59]

Roger Brown's family was notified shortly after the crash that he was missing in action but did not learn officially until September that he had died. Two months later, a memorial service for him was held at St. Paul AME Church. Speakers that day included Reverend W.T. Coleman, William Seabron and Reverend Hyman B. Mills, who remembered Roger as an intelligent man with a ready smile, soft-spoken yet blessed with a strong musical voice. Lieutenant Roger Barrett Brown is among those honored at Veterans Memorial Park. He was twenty-six.[60]

By the middle of 1943, the midpoint of American involvement in the war, there were approximately 4,500 African American officers in the United

The Little Migration

Lieutenant Roger B. Brown. *Gloria Foster.*

Insignia of the 100th Fighter Squadron. *Tuskegee Airmen, Inc.*

States Army; in the U.S. Navy there were none. As it had since its earliest days, the navy insisted that blacks were unfit to be officers because they could never assert effective leadership over white sailors or even live in proximity to them, particularly aboard ship.

Yet as manpower needs grew significantly in an expanding naval war, it became increasingly untenable for the navy to maintain an all-white officer corps when African Americans were being inducted into enlisted ranks at a rate of twelve thousand per month. A few blacks were finally admitted into relatively lengthy programs that combined college education with officer training. But the Roosevelt administration and civil

rights groups urged the navy to move even faster, with Eleanor Roosevelt lending important public support. They found an important ally within the service's own civilian leadership.

Adlai Stevenson, then legal adviser to Navy Secretary Frank Knox, wrote a memorandum in September 1943 that proved to be influential. Stevenson, who would soon be elected governor of Illinois and was twice candidate for president, argued his case in a dispassionate manner, presenting integration of the officer corps as inevitable rather than as an opportunity. Stevenson well knew that he was writing to a boss, Secretary Knox, who had little sympathy himself for African Americans and who relied heavily on the navy's uniformed leadership, a group more devoted to tradition than to progress. Nevertheless, in his memo Stevenson urged the navy's leaders to proceed without delay:

September 29, 1943
MEMORANDUM TO THE SECRETARY OF THE NAVY

I feel very emphatically that we ought to commission a few Negroes. We now have more than 60,000 already in the Navy and are accepting 12,000 a month. Obviously, this cannot go on indefinitely without making some officers or trying to explain why we don't. Moreover, there are 12 Negroes in the V-12 program and the first will be eligible for a commission in March 1944.

Ultimately there will be Negro officers in the Navy. It seems to me wise to do something about it now. After all, the training program has been in effect for a year and a half and one reason we have not had the best of the race is the suspicion of discrimination in the Navy. In addition, the pressure will mount both among the Negroes and in the Government as well. The Coast Guard has already commissioned two who were qualified in all respects for their commissions.

I specifically recommend the following:

Commission 10 or 12 Negroes selected from top notch civilians just as we procure white officers, and a few from the ranks. They should probably be assigned to training and administrative duties with the Negro program.

Review the ratings groups [rankings] from which Negroes are excluded. Perhaps additional classes of service could profitably be made available to them.

I don't believe we can or should postpone commissioning some Negroes much longer. If and when it is done it should not be accompanied by any

special publicity but rather treated as a matter of course. The news will get out soon enough.[61]

Within weeks, the navy's leadership decided—very quietly—to create an officer training program along the lines that Stevenson had proposed.

The service soon put out a call for sixteen highly qualified candidates. While little is known of the selection process, those chosen from the ranks had in each case shown exceptional leadership qualities during recruit training, combined with a willingness to accept discipline and obey orders. A number were excellent athletes, reflecting the navy's belief in a correlation between athletic achievement and leadership potential. Yet the group reflected a wide range of educational accomplishment: some had earned graduate or bachelor's degrees, others had attended college, while a few had no college experience. They brought to the program a variety of civilian occupations, including Pullman porter, bookbinder, security guard, mechanic, sheet metal worker, club director, teacher and attorney.

On March 18, 1944, thirteen of the sixteen—called the "Golden Thirteen" for the gold bars they wore on their shoulders—received their commissions as the first African American officers in the 146 years of the United States Navy. One of the thirteen was Frank Sublett.

Frank E. Sublett

The late Frank Sublett lived on Jefferson Avenue near Randolph Street.

I came to Glencoe when I was just about to start school. I was born in Murfreesboro, Tennessee, and moved with my parents to Highland Park when I was about four years old. My mother and father were both in domestic service. We all lived at their employer's house for about a year, when I moved to Glencoe to live with the Tom and Etta Brown family—Roger and his three brothers. In fact, we lived in the house right next door to this one.

Then I moved around the corner to the home of my aunt and uncle, Fannie and Lucius Talley. They lived at Green Bay Road and Adams. My aunt was a great cook, and for many years she conducted a catering business out of her home. She had a regular staff and catered parties and other events all along the North Shore. My uncle worked at the Glengables Tea Room on Park Avenue and then at the Hearthstone Tea Room in Hubbard Woods. I used to

Lieutenant (j.g.) Frank E. Sublett.
Frank E. Sublett.

go in with him before school, and sometimes after school, and help him clean and straighten up. I have always been regimented and well disciplined, starting from the time I was a kid, and that was my first work experience.

I was a member of Troop No. 25 over at St. Elizabeth Church. Our scoutmaster was William Baehr, who lived on Palos Road; he was white, while the troop was largely black. Mr. Baehr was a very open-minded person who became a great friend and mentor; he thought enough of my abilities as a leader to make me junior-assistant scoutmaster. He took our troop many places, mostly camping but also on outings to places such as Wrigley Field, and taught us all we needed to know about scouting and clean living. We also learned knot tying and lacing, which came in handy for me in the navy.

I've always liked being around the water, and I think that when I was considering enlistment, my early years may have had something to do with it. As a youngster I enjoyed going out with a .22 rifle to hunt ducks in the Skokie Marsh; we used to wade out there in the peat moss, which smoked away every fall. In the early mornings

I would go down to the foot of Harbor Street and catch fish for breakfast. And I always enjoyed the boating that my uncle and I did on our fishing trips to Wisconsin.

There were two churches in the neighborhood, the Baptist church at Madison and Vernon and the AME on Washington. I went to both of them, and also to Sacred Heart Church in Hubbard Woods. Those were Depression years, but the only thing I knew about it was that I had food and a home, and while I read about it and heard people talk about it, that was it. I went to the store practically every day for my aunt and uncle so there was no want for anything. In fact, I consider myself living today not that much differently than we did then.

After graduating from Central School, I went to New Trier and participated in a lot of sports, including football and indoor track and outdoor track also—shot put and discus and relays, that sort of thing. I played football all four years there; one year we won the state championship. We did well as a track team too, and I still have many records of my achievements in track.

I had a very good time in high school. I don't know if that was because I was an athlete or what, but I did my part. I was a study hall supervisor and I had a good adviser—J.C. Schumacher was the bandmaster and music instructor. And we had good coaches—John Nay and Paul Delaporte. People still come from everywhere for reunions.

I wasn't aware of color at that time. It was not brought up to me and I didn't think about it. There were only a few black kids in our class—4 out of 539. We all had nice associations with no problems.

After New Trier, I went to the University of Wisconsin, where I continued with track and football. I played end on both offense and defense; our head coach was Harry Stuhldreher, who was one of the famous Four Horsemen of Notre Dame, the backfield that played for Knute Rockne. I was there for a year and a half; then I went to Northwestern, and to George Williams College, which was then on the South Side.

Right after Pearl Harbor, Congress declared war, and I assumed I would be drafted because I was turning twenty-one that year. I wanted to get into the Army Air Corps, yet there was only one place, Tuskegee, for pilots to train; it was the only airfield open to blacks. But I was not accepted. So having grown up in this area

and always finding myself attracted to Great Lakes Naval Training Station, which I passed by frequently, I decided I wanted to get into the navy. And so I went to the Navy Recruiting Command and enlisted in July 1942.

I was shipped to the only place in the navy for blacks to go, Camp Robert Smalls at Great Lakes. This was a specially built area on the base; there was complete segregation in the navy at that time. I was in a company of 250, where I became a company commander, in charge of the group in boot training. This was the beginning of my experience in the navy as a leader, which probably helped my admission into the officer program later on.

General service ratings had finally opened to blacks shortly before I enlisted. Prior to that point blacks had been allowed only to be cooks or bakers, shoe polishers or valets, so I was happy that I could be in general service as a sailor. I took an aptitude test after completing boot training and was selected for the mechanics' mate school, which was in Hampton, Virginia. It was a good distance away from home and also for blacks only, though with a faculty that was entirely white. The other service schools offering that training were available only to whites.

The officer in charge at Hampton was Commander E. Hall Downes, who was a very caring and respected person. He was a good family man; he kept in touch with my mother while I was in service and gave her frequent reports on what I was involved in. I met him the first time, and the next time he could tell me my name and where I went to school and what I studied. He was like that with everyone else too. He was a good friend and a good commander.

I became a battalion commander at Hampton, in charge of several companies of 250 men each. We often had entertainers visit and perform, and on one occasion I had the honor of presenting Marian Anderson with a bouquet of flowers and thanks for attending our school program. Jazz musicians visited too. I graduated from there a second-class machinist's mate.

Next I was assigned to the Boston Navy Yard. I spent about a year there working with experienced machinists from civilian life, and I took advanced training in several skills. In late 1943, however, I was told suddenly to "pack my bags in seagoing fashion," which was the command to move out, and so, following my orders, I returned to Great Lakes.

The Little Migration

When I arrived, I was told only that I was going to become enrolled in a program to become an officer. The navy's idea was that they wanted the best from the top, although I feel there were people who were just as capable, that out of 160,000 black sailors there were more than just sixteen of us who were qualified. I had no idea who selected me, although Commander Downes may have had a hand in it.

All of us in the course got along well. We were open with one another, and there was a lot of camaraderie as we all learned new things. We helped each other and worked as one in the group, surprising them, I think, with the excellent scores we posted at the completion of training, a class grade point that has never been equaled at officer candidate school. Our instructors were good; most had been in service and all were white.

There was no graduation from the program. We were simply told it was over, and each of us was called in to learn whether we had passed. The three who did not qualify were never given any reasons, while the rest of us were just handed our commissions; nothing was made of it. But the navy did encourage local and

When a photo similar to this appeared in *Life* in April 1944 over the caption "First Negro ensigns," it prompted a flurry of reader responses ranging from highly critical of the navy to strongly supportive. Frank Sublett is in the top row at far right. *Frank E. Sublett.*

Frank Sublett as an enlisted mechanic's mate. *Frank E. Sublett.*

Lieutenant (j.g.) Sublett on duty in the Marshall Islands. *Frank E. Sublett.*

national publications to make a big deal out of it, and so the word got around quickly.

After that, I returned to Hampton, where I took command of another battalion. From there I went to San Francisco Bay, where I took charge of a converted yacht, and then was assigned to an oiler, refueling fighting ships such as aircraft carriers, destroyers and battleships. The fact is that the navy did not know exactly what to do with us. From there I went to Eniwetok in the Marshall Islands. The U.S. Marines had created an airstrip, and we operated there, loading and unloading cargo ships in preparation for an invasion of Japan. We watched the biggest fleet of ships and cargo carriers you can imagine—what equipment there was for the invasion! And then the next thing we knew, the war was over. I was married by then, so I soon left active duty and enlisted for ten years in the Reserves.

After many years as a service manager at the auto dealership that I had worked for before the war, and then at another dealership, I retired and started a second career. Through a neighbor across the street, I joined the actors' union and became a model. I did still photos and industrial films, and commercials for national clients such as Budweiser and Pillsbury. I've been a doctor, a pharmacist, a judge and a priest in robes. Once I portrayed Mayor Harold Washington in cahoots with Ed Vrdolyak.

The Golden Thirteen first reunited as a group in 1977. For many years we held our reunions jointly with the National Naval Officers Association, a professional organization for minority officers in the navy. Together, we have worked to encourage minorities to consider the navy, with the possibility of getting good schooling for a lifetime in the service or in another good livelihood. Today, the business world knows that the navy has given these officers the education and training they need, so the corporate recruiters are after them.

It's been quite an honor for us these recent years. In 1994, the navy dedicated the Golden Thirteen Recruit Inprocessing Facility at Great Lakes. It is the first stop for newly arriving enlistees—there are about forty thousand a year—as they prepare to undergo recruit training. The navy has come quite a way: from the thirteen of us, today there are over four thousand African American officers on active duty, a quarter of them women! I get a kick out of it when the neighbors' children tell me they see me in the history books.

DEDICATION CEREMONY

FOR THE

GOLDEN THIRTEEN

RECRUIT PROCESSING FACILITY

BUILDING 1405
CAMP MOFFETT, RECRUIT TRAINING COMMAND
NAVAL TRAINING CENTER, GREAT LAKES

5 JUNE 1987

The first stop of every new recruit at Great Lakes Naval Training Center is the building named for the Golden Thirteen. *Frank E. Sublett.*

Frank Sublett and his colleagues contributed their stories to The Golden Thirteen: Recollections of the First Black Naval Officers, *which was published in 1993. The book's foreword is written by General Colin L. Powell, chairman of the Joint Chiefs of Staff and Secretary of State, who wrote:*

> *The Golden Thirteen were not activists. None of them had sought to make history. The Navy's leaders had simply decided that it was past time to bring down the barriers to opportunity in the fleet; and as a consequence, these thirteen sailors were plucked out of their separate lives to learn the ways of officership.*
>
> *Yet from the very beginning they understood, almost intuitively, that history had dealt them a stern obligation. They realized that in their hands rested the chance to help open the blind moral eye that America had turned on the question of race.*
>
> *And they recognized that on their shoulders would climb generations of men and women of America's future military, including a skinny seven-year old kid in the Bronx named Colin Powell.*[62]

PART V

"Where Are All the Black People?"

In the early days, the Village of Glencoe and neighboring municipalities occasionally employed African Americans, but hiring was usually on a casual basis. By the end of World War II, no blacks remained on the payroll of any community between Evanston and North Chicago. Soon after Robert B. Morris was appointed village manager of Glencoe in 1951, he instituted a campaign to hire African Americans at all levels of village government, including sworn officers. Morris spoke with Glencoe residents and used other personal contacts to spread the word that while hiring would be strictly on merit, African Americans were strongly encouraged to apply. As a result of Morris's efforts, by the time of his retirement in 1982 African Americans comprised 25 percent of village employees, including 15 percent of supervisory positions.[63]

Another of Morris's initiatives was to institute a work-study program that provided capable students an opportunity to finance their college education by working for the Village of Glencoe. Morris advertised the program at a variety of schools, including historically black colleges, and accepted students into the program from Wilberforce University among others. For over twenty years beginning in 1962, participants worked in a number of positions in various departments while living in the police-fire dormitory.

During the same period, the human relations and open housing movements began to attract adherents along the North Shore, as many residents came to believe that continuing discrimination had to be addressed directly and that more affirmative efforts had to be taken to welcome minorities to North Shore communities. One early campaign was to begin to open area hospitals to blacks; that was undertaken in the mid-1950s. Individual communities, including Glencoe, soon formed their own human relations groups to encourage open housing and a greater awareness generally of the need for

improved racial relations, and Glencoe became an attractive choice for a number of African American families.

George E. Johnson was born in a sharecropper's shack near Richton, Mississippi, in 1927. His parents separated when he was two, and his mother moved to Chicago with George and his two brothers. George, who earned money from the time he was nine years old, graduated from Doolittle Elementary School on the South Side but dropped out of Wendell Phillips High School in tenth grade to take full-time work as a busboy. A succession of jobs followed; at one point, Johnson went to work during the day as a waiter while setting pins in a bowling alley at night.

Eventually Johnson joined Fuller Products Company, a pioneering black cosmetics firm. During the course of his employment there, Johnson became close to its founder, S.B. Fuller, who openly shared many of his business principles and practices with his ambitious young employee. As a result, Johnson came to think of Fuller as a mentor whose support helped sustain him throughout his career. (When Johnson Products suffered a fire in its early days, Fuller took in the entire operation and housed it until Johnson could rebuild—this for a budding competitor.)

George Johnson first worked in the Fuller sales department, but after taking a night course in chemistry he switched to research and development. It was while he was working there as a laboratory assistant that opportunity came knocking:

One afternoon, Johnson spotted a local barber coming out of Fuller's offices, looking particularly dejected. The barber told Johnson that he had been working on a chemical formula for straightening men's hair, and was having trouble perfecting it to the point where it would be safe to use. He had come to the Fuller people hoping to get some assistance, and had been turned down. Johnson stepped in and took over the project on his own, using the knowledge and experience he had gained in his research and development work, and the confidence he had acquired from Fuller himself. For most of the next year, Johnson devoted his nights and weekends to developing a safer and more effective hair-straightening product.

In February 1954, when Johnson was twenty-seven years old, he perfected the new hair-straightener at last. Deciding he would begin making and marketing the product as his own business, he approached several banks requesting a loan in order to launch the venture. After being turned down repeatedly, he told one bank that the money was for a vacation rather than a business, and he finally got his $250 loan. Assisted by his wife, Joan,

82

whom he had married in 1950, his brother Robert, and a chemist, Dr. Herbert Martini, George Johnson started the business in a rented storefront. Joan helped mix the formula and made up the packaging, and George traveled from town to town, selling the "Ultra Wave Hair Culture" from the back of his station wagon.[64]

In 1981, the Horatio Alger Association of Distinguished Americans honored George Johnson with its Only in America award. By that time, he had built Johnson Products Co. into a leader in the beauty care industry and the largest black-run manufacturing firm in the nation, with international operations and annual sales of $46 million. Its main product lines consisted of hair relaxers, conditioners, dressings, shampoos and cosmetics, marketed under brand names such as Afro Sheen and Ultra Sheen. Most of Johnson Products' 550 employees worked in a 440,000-square-foot manufacturing facility at 8522 South Lafayette Avenue that became a well-known and highly regarded source of employment for South Side residents.

As Johnson Products grew into an important member of Chicago's corporate community, George Johnson's business activities increased along with his civic and philanthropic commitments. Over the years, he served on the boards of the United States Postal Service, Commonwealth Edison Company, the Chicago Urban League and Northwestern University. At Johnson Products, George Johnson established a corporate foundation that assisted almost two hundred affirmative action programs in the areas of jobs, housing, health, education, youth services, legal justice and family planning. He also created the George E. Johnson Educational Fund, a personal foundation that provides financial support for black students in Chicago who would otherwise have little access to higher education.

Johnson has long had an interest in supporting black businesses. In the 1960s, he helped organize the Independence Bank of Chicago, the first new minority-owned bank in the city in a quarter century. From the beginning, Johnson, a director and principal shareholder, made certain that the bank went to great lengths to assist aspiring black business owners. He recalls that at one point Independence Bank was making more Small Business Administration loans to blacks than were all the other banks in Chicago combined.

George Johnson has been given honorary degrees by a number of educational institutions, including Fisk University, Lake Forest College and Tuskegee Institute, and he has received many other awards honoring his business and philanthropic accomplishments. In a review of his career in 1999, the *Wall Street Journal* called George Johnson "a shining symbol of black entrepreneurial success," his firm

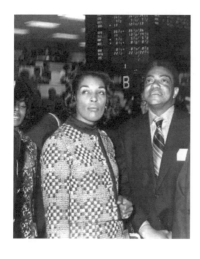

Johnson Products Co., trading as JPC, was the first African American–controlled firm to be listed on a U.S. stock exchange. Here Joan and George Johnson (second from right) observe the opening day of trading on the floor of the American Stock Exchange in January 1971. *George Johnson.*

"a nurturer and incubator for scores of future black entrepreneurs," and its Chicago plant "a shrine to black economic autonomy."

George and Joan Johnson and their four children lived for many years on Brentwood Drive.[65]

Charles R. Thomas

Charles and Juanita Thomas lived for many years on Dennis Lane.

I grew up in Evanston, on Brown Avenue, then on Emerson Street. My mother was a maid, my father a porter who later became a factory worker. I first went to Foster Elementary School, which was all black, then on to Nichols Junior High, which you had to qualify for by taking a test. By the time I was going on to high school, I believed that I could excel.

I had perfect attendance in high school—never missed a day. I knew then that I would become a teacher because I had good teachers there. One of the people who inspired me at Evanston Township High School was Lloyd Michael, the superintendent. He seemed to recognize something promising in me, and he and I became good friends. When I was in high school, he assured me that he would give me my first job out of college, and he was good to his word. I had a good athletic record at Evanston Township in football and track, mainly shot put and discus throwing. I was runner-up in the state in shot put and an all-state football player.

The Little Migration

Charles Thomas. *Tori A. Bronaugh.*

As a result of my record in both sports, I received an athletic scholarship to the University of Wisconsin. I really enjoyed those years, and I've been active as an alumnus ever since. Because my scholarship didn't cover all my expenses, I worked during my student days. One job was waiting on tables at the Pi Lambda Phi house; before long we all became friends, and the members asked me to join. I was the first black member of Pi Lambda Phi anywhere, although Rafer Johnson joined a little later at UCLA. It was a good group—there was Herb Kohl, who became owner of the Milwaukee Bucks and donor of the Kohl Center in Madison. Larry Hochberg, an executive who lived here in Glencoe for many years, was another. And there was Bud Selig, who was a little younger—he ran the Milwaukee Brewers, and now he is Commissioner of Baseball. We all had a lot of fun.

My scholarship was for football and for track, and I pursued them both at Wisconsin—I played varsity football for three years, and I was co-captain of the track team, where I became all–Big Ten in shot put. I've kept up my interest in athletics over years, and from 1973 to 1988 I was a member of the athletic board at Wisconsin, as well as representing Wisconsin on the Big Ten Advisory Committee. I put a lot of time into issues such as eligibility requirements for minorities and opportunities for women in sports.

After graduation, I returned to Evanston Township High School to teach social studies and coach football. I was the first African American on the faculty there. A little later I became a home room director—250 students every day—and after that an assistant principal. One of my colleagues in the social studies department was Michael Bakalis, who later became involved in public issues and became State Superintendent of Public Instruction. He asked me to become assistant superintendent in charge of the Chicago region, and I accepted. And while I enjoyed the work, I began to feel that the real challenge would be to take charge of a school district myself. While I was teaching, I enrolled at Northwestern and earned a master's and then a doctorate in educational administration. My doctoral adviser turned me on to North Chicago, and I went there as superintendent, first of an elementary school district, then of a combined elementary–high school district.

That is a place with a lot of promise but no money. We barely saved the high school from closing, but I had to spend much of my time on financial crises. North Chicago is mostly minority with substantial unemployment; our job was complicated by the fact that navy personnel send their children to our schools from Great Lakes Naval Training Station. I used to go to Washington frequently to lobby on behalf of our school district, and I had a lot of help there from our congressman, John Porter, who was a classmate of mine at Evanston. Herb Kohl had been elected to the Senate by then, and he helped us too.

I was a charter member of the National Alliance of Black School Educators. During my active years there, we commissioned "Saving the African American Child," which was the first such report to address the particular needs of black children. It was published in 1984. Until then, educational reform advocates paid little attention to black students and the particular stresses they encounter. Our report was well received, and when I took over as president of NABSE, we published a development plan. It included a demonstration project and an educational foundation to administer an endowment to help support the plan. It was the biggest effort ever undertaken by NABSE.

My late wife Ruth and I moved to Glencoe in 1960. We did so because in Evanston we were relegated to one section of town, and I could not see that for us. We chose Glencoe because it was a basically open community. Nancy King was a friend, and as it

The Little Migration

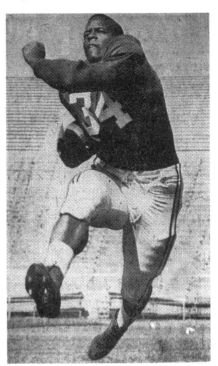

During the 1955 season, Charles Thomas led Wisconsin in rushing with 477 yards on ninety-eight carries and in scoring with six touchdowns—he was named honorary mention All American. That year Thomas was drafted by the Green Bay Packers—any Badger's dream—but after graduation he chose instead to teach and coach. Yet according to the university, Thomas "had his greatest thrill in sports" during his earlier playing days at Evanston Township High School, when in a snowstorm he took an opening kickoff and ran it back 82 yards straight up the middle for a touchdown—against New Trier. *University of Wisconsin.*

happened we first moved across the street from her grandmother, on Adams, then to Woodlawn Avenue, which is where our two sons mostly grew up. I served on the village caucus—our nominating committee for local office—and I was a member of the Glencoe Human Relations Committee. For several years, I taught Sunday school at St. Paul AME Church, where my sons grew up. While there were just a handful of black kids in my sons' classes, I was pleased with the public schools, because from there, the children had the pick of many good colleges.

Janet Williams and Jennifer Bluford

Janet and the late William L. Williams lived for many years at Linden Avenue and Harbor Street. Jennifer Bluford is their granddaughter.

JENNIFER: My grandfather, William L. Williams, was born in 1913 in Franklin, Kentucky. His parents came to Springfield, Ohio,

Jennifer Bluford and Janet Williams.
Karen Ettelson.

with the Great Migration, heading north in 1920. My grandfather remained in Murfreesboro, Tennessee, with two maiden aunts who were schoolteachers. He attended school there for two years.

Living in the South, he experienced segregation firsthand. On Saturdays, he went with his aunt to the downtown area to shop. The segregation he experienced there really made an impression on him. When he was about eight or nine, he joined his parents and younger siblings in Springfield, Ohio.

My grandfather graduated from Springfield High School in 1931. With encouragement but little money, he enrolled at Wilberforce University. While in college, he was employed full-time as a driver for the superintendent of the agricultural school. He graduated from Wilberforce in 1937 with a bachelor of science degree in education.

Jobs were scarce, however, in those Depression days, and you had to use whatever talents you had to make a living. My grandfather learned that MGM [Metro-Goldwyn-Mayer] had recently completed a number of black feature films that it released only in northern cities with large black populations. He had always been handy with a movie projector, so he and a friend rented projectors and prints of the films and headed off in a Mercury convertible for Louisiana. There, for the better part of a year, they showed the films—mostly Westerns!—before black audiences at rural churches and schools. They charged five and ten cents admission to those who could afford to pay, and then let everyone else in free.

My grandmother and grandfather met on Christmas Eve 1939 at the home of a mutual friend.

JANET: I lived in Urbana, Ohio, a town of about six thouasnd people, and I graduated from high school there in 1938. Next I attended Urbana Junior College, which was a private school operated by the

Swedenborgian Church. Then I took a job as deputy to the auditor of Champaign County, Ohio. It was at that time that I met Bill. He was working for the State of Ohio in Springfield, which was fourteen miles away.

Bill was inducted into the army in 1941. I remained in Urbana for a few years and then moved to Chicago, where I went to work for the Chicago Housing Authority as a secretary in the legal department. When Bill left the service he also moved to Chicago—he was following me—and a year later we were married. We first lived at 93rd Street and Forest Avenue while Bill worked for the Veterans Administration. Later, Bill moved to the Social Security Administration, where he was a claims officer and investigator.

JENNIFER: During the 1950s and 1960s, my grandfather was a civil rights activist and very active in community work, church organizations, voter registration and education projects. This included service as president of a neighborhood association and always fighting for better schools. He was involved at one point in a class action lawsuit in federal court that was an effort to improve the Chicago Public Schools for the benefit of minority groups.

JANET: Bill always attended all of the community meetings and was very involved in Gillespie Elementary School at 93rd and State, and then at Harlan High School, which was new at the time. Gillespie was virtually all black, while Burnside School a few blocks away had extra space but was all white. Bill worked hard to pressure the board to change the boundary lines so that children were able to escape overcrowding at Gillespie.

Bill's group worked hard on that federal lawsuit. They brought in a lawyer from New York State, who argued that there was disparity of treatment in funds given to schools for books and supplies; the plaintiffs sought more racial equity in this area.

A little later, just before we moved to Glencoe, Bill and I marched with Dr. King. It was in the summer of 1966, when he came to Chicago to work on open housing in particular. We were with a group from our church, which took an active interest in civil rights. I remember it was a warm day and that we marched up State Street into the Loop. There were large crowds along the sidewalks, mostly curious.

JENNIFER: While living in the city, my grandfather moved from the Social Security Administration to become Midwest region training officer for the Department of Health, Education and Welfare. There he administered training programs for employees at all levels, from clerical workers to top executives.

In the late 1940s, my grandparents visited a friend who lived in Glencoe. They loved the village and hoped to move there eventually.

JANET: I used to visit Dorothy Lewis, a friend who lived near Randolph and Jefferson. Her family kept a small house there that they used mainly as a summer home. Dorothy would invite my sister and me to come with her to Glencoe on the North Shore electric train many evenings during the summer, and we would spend the night. Sometimes we would spend the week with Dorothy; we would hop on the North Shore and go back to our jobs in the city—I was still working for the housing authority. If Bill and I attended Ravinia, we would stop by Dorothy's; she always had food prepared and invited a lot of people from Chicago to visit her on weekends.

JENNIFER: In 1966, because of overcrowded conditions in the Chicago public schools and the need for a larger home, my grandparents decided to make the move to Glencoe. They moved with their three children: my mother and her sister and brother.

JANET: There was a group in Winnetka that was promoting diversity in the northern suburbs. Through that group we looked at houses in several communities but liked the home we selected in Glencoe. And we had a five-year old son who was just starting school, so it was easy for him to roll out of bed and get himself off to South School just across the street.

JENNIFER: After living in Glencoe for several years, my grandfather was approached by Charles Thomas, who was a member of the village caucus, about running for village trustee. He was interviewed by the thirty-nine-member caucus and was put on the ballot in 1970. He was elected along with the rest of the caucus slate.

JANET: I remember Charles Thomas introducing the idea to Bill. It certainly hadn't occurred to Bill at first, but Charles thought it would be a very good idea.

The Little Migration

Bill served for a four-year term, and in 1974 he was reelected. I remember many late-night meetings; it was time-consuming. He would spend every night once a week reviewing the information he received from the village, going through it so that he would be prepared for meetings. Recycling was a major issue at the time, and he was very involved in that.

JENNIFER: My grandfather also became involved in the black parents' group at New Trier High School. The group was organized because some parents had concerns about the progress of black children, especially boys. The group wanted to make the school administration aware of the needs of black students, and they met with the superintendent and the school psychologist to make their concerns known.

JANET: I think this was an ongoing problem, something that hadn't been addressed in the past, probably because black parents felt they wouldn't be heard. We felt that the boys were ignored, not encouraged as much to achieve as they might have been. At one time, all the black boys used to sit in the back of the classroom together, and the parents wanted them to be more integrated and a part of the whole group. I think the high school might have heard, but I don't feel they did much to encourage change.

What resulted may have been greater sensitivity on the part of the school, but the black parents were also very interested in having more black teachers. This has never worked well here, because housing expense is always a consideration, but Bill felt that more effort could have been made to advertise for black teachers.

JENNIFER: From 1984 to 1987, my grandfather was a member of the Public Safety Department's pension board; from 1987 to 1990 he served on the Glencoe Public Safety Commission.

JANET: The Public Safety Commission is responsible for the hiring of public safety officers and interviews each prospective officer. Bill was always interested in trying to see that Glencoe have a more diverse force by advertising as widely as possible. In 1990, Bill was given the Caspary Award, which is for senior citizens in Glencoe who contribute time to public work such as, in Bill's case, his work on civil rights and voter registration, all the things he had done in

William L. Williams. *Janet Williams.*

the city before we moved to Glencoe. Bill passed away in 1995, so the Caspary Award came close to the end of his active career.

JENNIFER: My grandfather left us a legacy of public service. Among those he influenced was my mother, Carolyn Williams Meza, who became the first woman of color to direct a major urban park system when in 1998 she was appointed General Superintendent of the Chicago Park District. So we believe that my grandfather's good work in serving the public is being carried on today.

Carol Hendrix

Carol and the late William Hendrix raised their family on Madison Avenue near Vernon Avenue.

I was born at Community Hospital of Evanston. This was the only hospital in Evanston that would accept black patients and the only one where black doctors were allowed to practice. At the other hospitals, black people could come only to the back door, where they would try to get referred to a doctor.

Community Hospital was run and owned by Dr. Elizabeth Webb Hill. Dr. Hill went to the University of Illinois College of Medicine,

where she faced every kind of discouragement. But she received her MD and joined the staff at Community Hospital, which had been founded by Dr. Isabella Maude Garnett. Dr. Hill was the first African American hospital chief of staff in Illinois. I remember the little hospital that was in an old house. Then they built a bigger building, which I came to know well as an adult—when Bill and I were first married, I worked there.

I grew up in Evanston—my name then was Carol Williams. My parents were Ruth and Herbert Williams, and we lived west on Lake Street. I went to Dewey Elementary School, were there were few black children. But those were children's days and happy ones. After Dewey, I went to Nichols Junior High and then to Evanston Township. I was a cheerleader for two years—one of the first blacks and first females to be a cheerleader there. While I was friendly with the kids in my neighborhood, I got a job midway through high school. After that, I tended to socialize with the people I worked with. I think that because I was often in racially mixed situations then, moving to Glencoe later wasn't a stretch for me.

After high school I went to one of the City Colleges of Chicago, then to training at Mount Sinai Hospital to be an X-ray technician. That gave me a feel of what I might want to do, and after I was married I wanted to do more, so I went back to school to take more courses.

Bill was born in Monroe, Louisiana, in 1933 and came to Chicago as a child. He graduated from McKinley High School on the West

Carol Hendrix. *Glencoe Historical Society.*

Side, where he was valedictorian. Bill was always a very smart man, very education-oriented. After that he went to Northeastern Illinois University, where he got a bachelor's degree in criminology. Bill was a friend of one of the student nurses at Mount Sinai when I was there and living at the nurses' residence. We started dating then, and we were married at St. Andrew's Church in Evanston.

Dave Norris went to school with me, and I knew him well from growing up. After Bill and I lived in Evanston for a while, we decided to buy a house and looked at Glencoe. Dave was already on the Glencoe Public Safety force, and he urged Bill to apply—at the time, Bill was working at the post office and also for a caterer and at a gas station, too. So Bill passed his exams and joined the force. This was in 1968, just about the time we moved here.

When I first came to Glencoe, I was involved with the PTA and the Glencoe Human Relations Committee. I met a lot of people through that. The principal of South School at the time, Marilyn Kelm, was extremely kind, but she was not used to my kind of person who wanted to visit the school and see what's going on, especially not a black parent coming over to see about a white teacher. But she always welcomed me. And I wanted to be involved—to see what my child was doing. And they didn't always like it. There was another Glencoe resident, Vivian Harston, who was also interested in visiting the school. She would sit in on classes to find out why it was that all of the black children were placed around the edges of the classroom and if this had any kind of impact on their learning abilities. So there were others who thought the same way.

Lonnie Barefield and I started Concerned Black Parents basically over the fact that the schools in Glencoe weren't doing anything for Dr. King's birthday. I sent a note to South School to ask what they would be doing—would the children be sent home from school—and said that if you are not doing anything, please send my child home, because I want this to be celebrated.

Well. They sent a note saying that they weren't planning to do anything that year, but they would try to do something the next year. That wasn't good enough for me—it was Martin Luther King's birthday *this* year, and I wanted something done *this* year. I meant to let people know, we're here, and you're going to give us the kind of attention that we do want, not the kind we don't want. So when the teacher replied that they would try to do something next year, that just wasn't good enough.

The Little Migration

So Lonnie and I said we would do it at our own homes, so we read up on Kwanzaa, other things. This was around 1977. And we did celebrate at our houses. And the group started meeting at that point. Included in our group were a number of mixed couples who had no one to turn to. We got a list together and called a meeting.

We told them we were concerned about the treatment of our children in the elementary schools, and we asked for a meeting with Dr. Charles Young, the superintendent. We met with him over a period of several years, and he really tried to be as responsive as possible. We developed a good working relationship.

When our children got to high school, we became active there. We felt that the teachers were not inclusive—they didn't try to include the black kids at all. I think they're still not encouraging the kind of inclusiveness that is a healthy thing for these children—they should be talking and learning from each other. New Trier's line of thinking was, well, we love all children, we teach all children. But my child is not all children; my child is a black child, and this is something that our families live with day to day, and they want to make sure that their children know why these things are going on, what has caused things to happen. I remember as one of the few black children in an all-white school, I never really had an opinion about a lot of things because I wasn't allowed to have one. The white teachers were intimidated by it; they shut me up pretty carefully. I remember asking my social studies teacher, "What happened to all the black people? I don't see black people. What happened to them? Where did they go?" That was the teacher who told me that black people were happy people, that they were happy-go-lucky people. And that puzzled me: "Happy-go-lucky—what does that mean?" And that was a teacher giving me that information, so what book do I go to so that I can find out about that?

Our Concerned Parents group wanted to put a black person on the New Trier High School Board, someone who thought inclusively with black children in mind, because we weren't thought of, it just wasn't important to them. I think the whole cause of race in education is just ignored. There is no program that encourages the races to come together and interact on an intelligent level and become human beings with each other, to humanly relate. We don't have the races come together here; what we do is have a dinner, an interfaith service. And what do we do there? Sing a hymn? What does that do?

Lieutenant William Hendrix. *Glencoe Historical Society.*

During those years I also worked on a program for the Department of Housing and Urban Development. My job was with the Leadership Council for Metropolitan Open Communities, which worked with HUD on ensuring that certain numbers of housing units were set aside for low-income and minority applicants. I went before a lot of village boards that wanted to know, why are you bringing these people here to live? My answer would be, because this is the United States of America, and we all live under the law. I would make certain that landlords who received federal funding offer housing to people of color—black people, specifically. I was with the Leadership Council for eleven years.

Bill started out on the Glencoe force as a Public Safety Officer, which includes police work and firefighting. In 1974, when he was not promoted to lieutenant after being passed over in favor of others, he filed suit in federal court against the village. Dave Norris, who had also not been promoted, joined Bill in claiming that they were not given the promotions they deserved because of racial discrimination. The case was settled out of court, and in accordance with the settlement, Bill was given the next available opening for lieutenant. The village agreed to improve its promotion procedures as well.

Bill loved Glencoe; we raised our son and daughter here, and he wanted this to be home to him for the rest of his life. From the way that people said goodbye to him, they indicated that he was someone they loved also. Bill retired as commander, but even after that he continued to be Officer Friendly. He had time for everyone;

he would sit on the porch and talk with residents. He always had time for that. Bill watched out for any signs of profiling and made sure it was discouraged, because it was not the Glencoe way of doing things. He was a proud man and proud of this village, and he didn't want anything to even appear to tarnish it.

Lun Ye Crim Barefield and Morris Barefield

Lun Ye "Lonnie" and Morris Barefield live on Randolph Street near Madison Avenue.

LONNIE: I grew up on the West Side of Chicago, near Lake and California. Both my parents were teenage parents, 17 and 16, when I was born in 1942. After eighteen months of marriage, my mother moved us to her mother's home, where I lived with my mother, grandmother, aunt and two cousins into my teen years.

In our house, there were three strong women. My grandmother provided the foundation for our family with very strong values, a humanistic type of value system that I think she passed on to all of her female relatives. She embraced people; anyone in need of housing, or with a need to take refuge some place, it was at our house. We "adopted" some people who would come and stay for a little while, just to help them out. One came for two days and remained four years.

My mother was the friendly one, who knew everybody from the highest to the lowest ranks of life, while her sister was the sophisticated one, who promoted cultural and educational opportunities. We went to the ballet and other cultural events where we at times experienced discrimination by being relegated to the back, or overlooked. My aunt would not stand for that. She would ask to see the top person there, whether it was the Opera House, Woolworth's or Marshall Field's, any place. Regarding our education, she never asked you if you wanted to go to college. Rather, she was constantly saying, "Well, when you go to college…" So you always knew that that was the next step no matter what: whether you could afford it or not, you were going. That's just the way she was.

I graduated from Tennyson Elementary School and John Marshall High School. I did well in high school and graduated in 1960 as a member of the National Honor Society, and I was also one of the four black females who were officers of the graduating class—I was treasurer and assisted with the presentation of the diplomas at

Lonnie and Morris Barefield. *Karen Ettelson.*

graduation. We had quite an integrated school at the time, mainly black and Jewish, with some Hispanic students. I feel fortunate that all through my school years, I was part of a club of thirteen males and thirteen females. We all stuck together, and those friends became an important part of my world as I grew up.

My paternal grandmother decided to move from Chicago to Carbondale in 1958. In Carbondale, she opened her home to girls who wanted to go to school there. I think that in her mind, she was making a place for her granddaughters. So I enrolled at Southern Illinois University with a cousin and two of my friends from home and lived with my grandmother for the entire four years.

Morris and I met just after I arrived in Carbondale, and we married at the end of my junior year. When I graduated, we both worked for the same school district, 218, Morris in Blue Island and I in Robbins, the next community. Then Morris started his teaching career at New Trier in 1966, and we moved to Glencoe a year after that. Our son was soon born, and then my daughter five years later, so I stayed home until 1976.

After a year at Waukegan West High School, I joined the counseling department at Evanston Township High School, where I remained

for 23 years. First I was a general counselor, then for eleven years I was the first African American college career coordinator. This required personal counseling, advising and developing a center that would provide college and career counseling options for the ETHS community. Since my retirement I have worked as co-facilitator for the ETHS black caucus, a group of black teachers. Our purpose is trying to help bridge the achievement gap between blacks and whites at the school, and we have developed a number of programs to support students, parents and faculty in this mission. I have also returned to community service and organizational involvements on a full volunteer basis.

MORRIS: My parents were reared in the little town of Grand Chain in southernmost Illinois, near the Ohio River and Kentucky. My dad finished sixth grade, my mother eighth grade. Later, they moved to Madison, Illinois, near St. Louis, a place of steel mills and heavy manufacturing. I was born there, the eighth of ten children. My mother was one of the best psychiatrists there was without a formal sheet of paper; she encouraged us to grow and challenged us to pursue our dreams. In my family, the males tended to go into military service, the females into nursing or government work.

One of the positive experiences early in my life was attending Dunbar Elementary School in Madison. This was a segregated elementary school. All of the teachers were extremely good; my inspiration to go into teaching came from my sixth-grade teacher, whose strategy was to form groups and find leaders for the group. So there were leaders who were strong in math, while others were stronger in English. After an eighth-grade teacher asked me, as a sixth grader, to help his students with their math, I decided I wanted to be a math teacher.

Next I went to Madison High School, an integrated school yet one with no black teachers, no one that you could really confide in. Aside from a few teachers I admired, there was not a lot of inspiration that was coming out of that school. And while I wanted to go to college and received a scholarship to go to any state school in Illinois, I still didn't have the resources, so I signed up for the air force. Just as I was about to ask my mother to sign my enlistment papers, a friend urged me to join him in attending the new campus of Southern Illinois University near Alton, about ten miles away. I commuted there from Madison and later transferred to the main campus at Carbondale.

When I graduated from SIU in 1961, I went to teach in Blue Island and then in Oak Lawn. During that time, I went back to Carbondale for summer institutes while I was working on another degree. It was there that I met Dr. Marian Moore and "Mike" Berry, two members of the math department at New Trier. The institute was composed of high school math teachers from all over the country, and once we got back to the dorms, a lot of them found that they didn't understand what had been covered that day. So they would come knocking on my door, sometimes until two or three in the morning. Dr. Moore and Mike learned of this, and we became closer. Before long they asked me to join the New Trier faculty.

I was hired and became the first black classroom teacher at New Trier East. In the first years, I had some experiences that were on the negative side, but very subtle. For example, at the beginning of the year I would see a student for a day or two, then the student would disappear. That was probably the result of the parents requesting a student be removed from my class. And while no one ever shared that directly with me, I was suspicious as to the reason. But by my fourth or fifth year there, parents were requesting that their son or daughter be *in* my class. Eventually there came to be so many requests that the school switched to a system of random placement.

After the Big Snow of 1967, Lonnie and I decided I should be a lot closer to my job than the South Side, where we were living. The fair housing groups were active then and sent us listings for houses in several North Shore communities. We found this house and liked this neighborhood, which offered more diversity than anywhere else we looked.

I spent 32 years at New Trier, and in addition to my teaching duties, for thirty of those years I also served as an adviser. In New Trier's system, a faculty member who has agreed to be an adviser is assigned 25 to 30 freshmen, male teachers to boys, females to girls, who meet as a group with their adviser every morning over the four years. Advisers also try to get to know the parents, visit the home and build lines of communication so that you can talk about the good times for the student as well as the bad times, the positives as well as the negatives. In this way, an adviser becomes the link between the home and the school. When a parent asks how the advisee is doing in a particular subject, or in all of them, it is the adviser's task to track down the teachers involved for status reports. You are a resource to other teachers in the building, too, so that if

a teacher is having problems with a student, the first person they turn to is the adviser.

Being an adviser is an excellent opportunity to get to know the whole student, not just his academic performance. You get to know each of them as individuals and try to establish bridges so that the student feels comfortable enough to come up to you and open a conversation about any issue he thinks is important. For example, there are always many discussions about college; students often come in to talk about that, about preparations and so on. This is important because one of the duties of an adviser is to write a characterization of each student that is sent to the college counselor.

The freshman year is critical, because then the student is more open. As he grows, he doesn't share his thoughts as freely, but as a freshman he is more open to issues that a junior might not want to discuss. Therefore, you build that relationship in the freshman year. By the time he's a junior, you've built it, so there is still an open communication, one that sometimes extends into college and beyond.

This is an unusual system, and a costly one. As a teacher, your role as an adviser takes up one-fifth of your load, so that one-fifth of your salary, you might say, is devoted to this responsibility, not to the fifth class you would otherwise teach. In fact, the time spent as an adviser is a good deal more than a fifth class would take: students drop by all day long to talk with you, and then you often spend time in the evening on the phone with parents. And while some students find a classroom teacher they get along well with, I think the adviser system gives every student the chance to have someone to work with who doesn't give a grade or hold anything over your head. It was a true relationship between you and the student. And you had four years to develop it.

When people learn where I worked, they often say, "Oh, that school, the one that has everything." I do think that at New Trier, if something is deemed to be of educational value, they usually have the resources to obtain that something. That goes for attracting talented teachers as well. And the adviser system, in which teachers spend so much of their time counseling students and helping them deal with both their educational and social development, is another tremendous investment. But I think that what makes the school so successful is not just the program or the facilities, but the parents, teachers and administration all functioning so well together. It is an advantage that I see when I talk with faculty at other schools, especially that parents at New Trier are so involved, open to communications

from the school and willing to come in to confer with the student's adviser or teachers. Whether New Trier's approach could be applied elsewhere is a question, but it is certainly worth looking at. Once we decide that education is one of the most important issues for this country, and that we are willing to put the resources into education that we devote to wars, then it could be done.

LONNIE: As far as our own son and daughter are concerned, I think the academic programs of both our elementary and high school districts have prepared them well to be successful individuals in the world. And a plus in this community is that the teachers know the families and they know the children. In that way, their growing up here is much the same as it was for me where I grew up. It seems to me that Glencoe has a homey, family-oriented atmosphere even more than in other communities around here and that our kids were reared in a place where they were nurtured by people who really cared about them. That had nothing to do with race, but simply how the children were treated as human beings.

However, in our early days, any elements of diversity had to be part of the home experience, not at school. For instance, several parents felt that letting kids out of school on Martin Luther King Day wasn't enough, that the children needed to know more about what they were celebrating. So a group of us sought to provide information on black history and related topics during the time we were parents in the Glencoe schools. Carol Hendrix and I, in particular, began to speak to the schools on behalf of other black parents who were not at home during the day. We found the teachers and principals responsive, and the curriculum did improve.

Socially is where the biggest rub comes in for being in a community such as this. For boys, it's not quite the same, because boys more often have sports, and that was the case with our son. Our daughter, on the other hand, had more diversified relationships through St. Paul Church and also Jack and Jill. That is an organization that was formed to allow black mothers and their children to meet other families nearby. The parents are sometimes employees of large companies that transfer executives around the country, and often it is difficult to get to know others in the area. So Jack and Jill offers both the children and the parents a place to develop social relationships, and through its programs, children also develop a

The Little Migration

Morris Barefield with one of his final algebra classes. Shortly before his retirement from New Trier High School in 1998, students organized a tribute they called "Hug-A-Bear Day." Buttons and T-shirts with Barefield's likeness were passed out and students were urged to greet—and embrace—Barefield during the day; to notify the community, organizers mounted the biggest thing they could think of—a thirty-foot balloon with a sign reading "Thank You Mr. Barefield." *Morris Barefield.*

cultural understanding of the race itself. Our North Shore group included families from Evanston to Lake Forest.

When our first child entered New Trier, we joined Concerned Black Parents, a support and liaison group that had been formed earlier. The group dealt mainly with sensitivity issues and also with curriculum matters, both at the elementary and high school levels. We met in the evenings and visited New Trier a number of times. If there was a concern over a particular teacher, then that would be shared, such as that a teacher was having a particularly difficult time relating to black students, or they didn't give the same kind of treatment that they gave other students. The administration was open to our comments, and usually the problem was resolved. At that time, most black parents lived in Glencoe; today, there are fewer students and they are more widely dispersed in the township, so Concerned Parents is no longer active. And also today, most parents are professionals themselves and therefore comfortable taking care of the needs of their children on their own. If there were common issues, I think they would come together, but if it pertains just to their own son or daughter, there is no need to come together for that.

When I was at Evanston Township High School, we had a concept that there is no limit as to what you can do, that you go for it. I think one of the most important lessons my children, or any children of color, can learn is that they can do anything that their white counterparts can do and that they should not let other people stop them from doing what they believe they can do. I tell the kids to say: "You can't tell me that a certain college is not going to accept me; let me apply and let the college make that decision." At New Trier, I had the sense that this was not emphasized to the same degree, and that was a concern.

My own approach is that in order to know your environment, you have to be involved, and something that I certainly garnered from my rearing on the West Side is that the family takes care of the family. I see involvement in the community as a form of protection, in the sense that you take care of your own. Therefore, you give to it, and it gives back to you. That is basically where I am in the community or in anything I do: if I am going to be dealing with it, I've got to be in it. I don't need my name on it, but I have to be involved physically. So when I first came to Glencoe and started attending St. Paul AME Church, I met a neighbor, Mr. Willie Johnson, who wanted to get black residents more involved in the electoral process. He asked me to work at the polls, and that was the beginning of my activities in the community.

I have been on the board of the junior kindergarten, the Glencoe Human Relations Committee, the Glencoe PTA, Village Caucus and St. Paul AME Church Women's Auxiliary. I served on a task force advising Public Safety on gun issues, and I became a member of the village caucus. In 2001, I was elected a trustee of the Glencoe Public Library.

I think that in my community activities, I have served as a sounding board and a reflecting board for others. My involvement always seemed to lead to somebody saying, "Well, Lonnie, what do *you* think about such and such," which then prompted me to present my opinion, my reaction, whatever, about the issue at hand. Yet at certain times, at meetings of the general community, I believe that just my presence mattered, aside from anything I actually contributed: people saw that there was someone representing a part of the community, and they became more aware and more understanding. I also tried never to aggravate a situation, because I think that people believe what they believe until they learn better. And so I would rather be a model than an antagonist.

James O. Webb. *James O. Webb.*

James O. Webb

James and the late Frankie Webb lived for many years near Wentworth Avenue and Old Green Bay Road.

I was born in Cleveland, Ohio, in 1931. I remember my early days of living in what was then called "the projects," public housing, but very nice public housing. They were garden apartments, and I remember having some good friends and great times, playing baseball and things of that nature. So it was a little bit different than the way we think of public housing these days.

We lived there until I was about nine years old, in fourth grade, then moved to the Glenville area on the east side of Cleveland, primarily consisting of Jewish families. When we moved in, there was one other African American family living on the block, but over a period of years, the community changed as many communities did back in those days—it was a gradual change, though, from white residents to African Americans. By the time I finished high school, in 1949, the area was about 30 to 35 percent African American. But in a primarily Jewish community, I had some interesting experiences, in that I was unable to play with many of my friends until after

Hebrew school was over, and I remember sitting on the steps of the Hebrew school, waiting for them to finish so that we could go play baseball. It was a wonderful existence and a wonderful childhood. We had a good school system there in Glenville.

When I finished high school, I wanted to go to Ohio State where most of my friends were going, but my parents insisted that I go south, to Morehouse College. They made it very clear to me that they felt I had grown up in a somewhat isolated environment, and they felt that I really needed a more realistic exposure to the world, and that was to attend an all–African American school. And so, against my protestations, I ended up going to Morehouse, and as you can imagine I did not enjoy it the first six months or so because I was not where I wanted to be. But I did learn to enjoy it, and as a matter of fact very much, and I am still a very strong supporter of Morehouse College, which was an all-male school then and still is, one of the very few men's schools in the country. In those days, our total student body was maybe four hundred students; my graduating class consisted of about eighty men, from around the country, although most of them were from the South, all African American. This was a time when a number of people who would later become prominent were students there—Martin Luther King Jr. graduated the year before I entered, and Maynard Jackson, who became the first black mayor of Atlanta, was there then too. And in those years I did learn a great deal about my culture, about my people and about myself. One of their objectives was to instill in Morehouse men the confidence that they could become successful, and the school told them how to be successful, by hard work and dedication, commitment and focus, things of that nature. I think it will always remain a small school.

So far as my own social life was concerned, I did have problems. My parents were correct: when I went south, I had no idea of the customs, nobody had forewarned me, and I got into difficulty the minute I got off the train and saw my steamer trunk being hauled away by a porter. As I walked past it I asked him when he thought the trunk would be delivered. He ignored me—he was a white fellow—and I thought he didn't hear me, so I said again, "That's my trunk, can you tell me when it's going to be delivered to the college," and he looked at me and said, "Are you speaking to me, boy?" And by that time, a couple of upperclassmen who had met me at the train had each grabbed one of my arms, lifted me off the ground, and

were walking with me, very rapidly, out of the train station. So that was my first exposure, which I didn't understand at all. After a few more incidents like that, believe it or not, the college decided that for my own safety, that they should confine me to the campus for the balance of the semester. So I could only leave campus with a senior classman going along with me. But that was one of the lessons that I had to learn, and that was the culture at that time, that I could not do the things in Atlanta, Georgia, that I could in Cleveland, Ohio.

My social life did take a turn when I met my wife, whose name then was Frankie Lowe. Frankie went to Clark, which was a coed school that was also a part of that Atlanta University complex, located just across the street from Morehouse. Frankie was born and grew up in Atlanta, on Auburn Avenue, a very historic area because it was really the seat of the African American economy. Atlanta and Durham were the hotbeds of entrepreneurial activity for African Americans going back many years into the 1920s and '30s. Frankie's family lived on Auburn Avenue across the street from the famous Ebenezer Baptist Church, which was Reverend King Sr.'s church. She had grown up with the King family, who lived next to the church; they were all very good friends. Frankie used to say that Dr. King Jr., or "M.L.," as she called him, had a presence that was always felt whenever he was around, even then, as a young man. When his older brother would have friends over, often including Frankie, there might be some beer or some alcohol floating around. If the word was out that M.L. was coming, or in the house, they would be sure to put on their good behavior and stop the partying. He just had that kind of impact on them as a young man.

So when we decided to get married, the King family would be the ones to participate in that wedding. When I first starting dating Frankie, I remember the first time that I visited her on Sunday, went to church with her, I was sitting up in the balcony, and Frankie was in the choir. Reverend King Sr. actually announced that there was a young man visiting there today from Morehouse College, who is dating "our Frankie," and I would like him to stand up so that you can see him. So I stood up, and I guess that was my approval. After that I became quite close to Reverend King; I liked him a great deal, and we enjoyed each other's company.

I knew by then that I wanted to study actuarial science. So after my military service, which took Frankie and me to Alaska, we

moved to Ann Arbor, where I worked on my master's in business administration at the University of Michigan. Most actuaries receive a master of science degree, but since most actuaries end up in key administrative positions at insurance companies, Michigan decided to experiment with an MBA in actuarial science, so that's the program I went through. I think there were twelve of us; it was a wonderful experience.

The problem came when it was time for me to get my first job. We had 30 or 40 insurance companies coming to interview the twelve of us. Actuaries were scarce in those days; there were only 1,200 in the country, and 1,600 insurance companies. Since there weren't even enough actuaries to cover the insurance companies, we were in pretty good demand. Even though one of my professors, who was Jewish, told me I would be wasting my time with any but New York or Connecticut insurance firms, as he himself had discovered after graduating, I decided to remain on the list for a company in Birmingham, Alabama; it was purely being devilish, I guess. The interviewer was sitting in a classroom, and he called for the next person while his head was down, writing notes from the previous interview. I got halfway across the room before he looked up and saw me, and I was having fun. I sat down, and I remember he had red hair. His face turned to just about the color of his hair. He just didn't know what to do. He did go through with the interview, but it was a symbol and a symptom of the times. I did get a couple of offers out of New York, and we ended up living there for five years while I worked for Mutual of New York.

That was an all-white environment. There was a black company here in Chicago called the Supreme Life Insurance Company that was having some financial difficulties. At that time there were about forty black insurance companies in the country, and so far as African American business was concerned they were the backbone of black entrepreneurial activity. There was one in Los Angeles and Atlanta, and two in Chicago, Supreme Life and Chicago Metropolitan. North Carolina Mutual, in Durham, is actually one of the biggest and most prominent.

Supreme Life had been told that in order to keep the doors open that they had to hire an actuary. Earl Dickerson, who was head of Supreme Life, had been the first black to receive a law degree from the University of Chicago. He was the head of the Chicago Urban League and the Chicago NAACP and

first chairman of the Fair Employment Practices Commission in Illinois. Dickerson was a real powerhouse, very politically connected, a real kingmaker. He would come to New York and wine and dine me at the Bull and Bear at the Waldorf-Astoria, where he stayed. He was a delightful man.

Finally I sent Dickerson a letter, saying that I would be willing to consider coming to Supreme Life if I could become assistant to the president, be an officer of the company, receive a certain salary with an increase every year for the next four years—I mean, just ridiculous stuff. He never answered the letter, and so I said okay, fine, that's okay with me; we can now settle down and buy a home, which we did, in Hempstead, Long Island. A year later, I got a call from him. He was in town, saying "Webb, I'd like to meet you at the Bull and Bear for lunch." I told my wife, don't worry. So we had lunch, and as we finished, he said "Webb, we really want you to come to Supreme Life. Here's what I'll do for you." And he rattled every single thing that I had asked for. Never acknowledged receiving my letter, never did to the end of his life. So that's what brought me to Chicago. That was in 1962. I worked for Supreme Life for four years and then became senior vice-president of BlueCross BlueShield of Illinois, where I worked until my retirement in 1984.

Soon after I joined BlueCross BlueShield, I became a founder and first chairman of the Home Investments Fund. The Fund really was an outgrowth of Dr. Martin Luther King Jr.'s visit to Chicago in 1966. One of the issues that Dr. King recognized was the segregation of communities and the hatred that he felt resulted from the fact that people were living in isolation from each other. So there was a strong movement to integrate Chicago neighborhoods and Chicago suburbs.

The Home Investments Fund was the result of the recognition that even though there had been a number of communities, particularly on the North Shore, that had passed open housing ordinances, no one was taking advantage of them—black families were not moving to the suburbs even though now they could. In those days, the mortgage was a conventional mortgage. In other words, you had to have at least 20 to 30 percent down. African American families did not have that kind of money because they had not accumulated it. Many of them had just been promoted into positions where they were beginning to earn very good money, but they had not had money over the years, they

did not have a rich uncle they could go to and say, can you loan me the down payment, I'll pay you back. They just didn't have the wherewithal to take advantage of open housing ordinances. So the Home Investments Fund became that banker, that rich uncle who would loan them the money for the down payment to move into a predominately white area. The reason that we were doing this wasn't only to help individual families. We felt that nothing was going to happen in a community until you had a reasonable number, not knowing exactly what reasonable was, but a reasonable number of African American families living in a community. Then others would feel more comfortable taking advantage of the open housing ordinances.

We did a number of things. We publicized the communities. We made sure that African American families were aware of what kind of a community Glencoe was, or Winnetka, or Wilmette, or Deerfield or so forth, so that they saw their opportunities. Then, secondly, we provided the financing for them to move in if they found a home that they liked. The way that we got that financing was to ask investors. We had church organizations that donated— we had a pool of about $300,000 that we raised from church organizations and private individuals. We shared offices with the Chicago Conference on Religion and Race, another organization inspired by Dr. King's activities in Chicago. I was very proud of what we accomplished. We opened up so many communities. As a matter of fact, when we looked at the 1970 census, we could look at the suburban communities around Chicago, and if it said, "four families" in a given suburb, we knew that maybe two of those families were "our" families. So we could see the good that we were doing, because we knew then that we are having an impact there, we helped two to move into that community. When we closed the Fund, we turned our operation over to the Leadership Council for Metropolitan Open Communities, another organization that was a consequence of Dr. King's Chicago days.

After living in Hyde Park for five years, our two daughters were growing up; one had entered Ray Elementary School. But we decided that we really wanted to have a home rather than renting. So we decided to look north. We drew a little bit of a radius around Chicago, and it turned out that we really didn't want to go much further than Wilmette, so most of our looking was confined to Evanston and Wilmette.

The Little Migration

But at the suggestion of our realtor, the very last home that we looked at that season was in Glencoe. We were really newcomers to Chicago and pretty much confined to Hyde Park, so we really didn't know much of anything about the suburbs, never really traveled north of Chicago at all. I do remember the impact that Glencoe had on me when we drove to it for the first time—the trees and the beautiful homes—I just had a good feeling about the community in general before I even saw the house. Believe it or not, our real estate broker lived across the street, and behind her was the home of her boss, who was a prominent broker in Glencoe at the time. That impressed us that we're moving into a community, and there were no African Americans east of the tracks at that time—I think she shared that with us—and so it was somewhat of a breakthrough for an African American family to move into a home east of the tracks. We bought the house in 1967.

Very quickly, we became involved in the community. Frankie worked in the schools, through the PTA and classroom events, while I became involved with the Glencoe Human Relations Committee, which had among its goals the passage of an open housing ordinance in Glencoe. There was a great deal of commitment to that effort, and the ordinance was enacted in 1968.

I worked for many years with Carol and Lonnie on the Glencoe schools. What the schools were saying then is what so many were saying in those days: they wanted to be color blind, they wanted society color blind. And we were saying, no, we want you to recognize us for who we are, we have some issues; you know, when our children go into a classroom and sit in the back row, that's an issue. You don't have that issue with white children sitting in the back row, but when black children do that, if you see them all sitting there, that's an issue, and you have a responsibility as a part of their growing up, and a part of their education, to get them to sit up front. It's a part also of their self-image, development of good quality, positive self-image. That was our point: that we did not want our children seen as any other children because they are not like any other children, they are black children that bring to you black problems and black issues and a black way of thinking, and we charge you with the responsibility of working with them and helping them through that developmental stage of their lives.

In 1971, I was asked if I would go on the Glencoe School Board, to fill a vacancy. I was appointed to finish a one-year term, and then I ran for two terms on my own, each for three years. So I ended up

serving seven years, the last year as president. It was a very good experience, and I believe that I was able to get some things done there from the perspective of the African American parents in Glencoe.

First of all, the presence is so important. Just having an African American sitting in a position of power and influence to contribute to the discussion, or not even to contribute but just simply to be there, causes other people to become sensitive and aware of an African American issue. When that hits the table, frequently I wouldn't have to say anything; other people would—their eyes might land on me, and immediately they would become sensitive to these things, saying, we had not considered this from an African American's point of view. And I wouldn't have to say anything. So, just my being there made a difference; the principals knew I was there, most of the teachers knew I was there, and so it created in them an awareness that what I am doing is going to be noticed, and therefore I need to be sensitive to these things. And, as we found over the years, so much of what doesn't happen for African American children is not someone making a decision that we're not going to do this, or we are going to treat them this way, or that way. So much of it is just insensitivity to the need of African American children. So once that sensitivity and that awareness is there, I'd say well over 50 percent of the problem has been solved.

Charles Young, then superintendent of the Glencoe schools, I came to respect more than anyone that I have had these kinds of controversial discussions with, discussions about fairness and race and things of this nature. Charles essentially became a student; he wanted to know, to understand. If it required him to ask questions, lots of questions, he would do that. But he wanted to do the right thing, and he recognized that in order to do the right thing, he had to understand thoroughly. And so he set about doing that, not just by asking me but by meeting a number of times with individual black parents and others. Charles made a difference in the Glencoe school system that I think is a legacy for him. I hope that it continues. But he certainly had a positive impact on the school system as a result of his attitude.

The administration and faculty were important to the process as well, because that is where the rubber hits the road. When they know that there is someone in a powerful position that can influence their lives and had a particular interest in something happening, they behave differently. For the same reason, if there is someone on the school board who is known to want language dealt with in a

certain way, the system is going to be sensitive to that, and they're going to react accordingly.

I also spent a good deal of time on New Trier High School. That was a very, very difficult situation to deal with, since we were up against people who wanted to appease us without really changing anything. I ended up knowing a lot of people at New Trier, and I think they respected my fairness and my objectivity, that I really debated the issues with them. At times Carol and Lonnie would ask that I get involved, while at other times it was the administration that would ask me to get involved. This continued for a number of years, but I could not change the mindset on the part of the school as a whole, that to do anything differently was an interference that would be time-consuming, wasteful and nonproductive. That's the way they viewed it.

One of the things we wanted New Trier to do was to raise the level of awareness—we didn't want to be the ones who were always having to point things out to them. So we suggested that they really needed a human relations committee of their own at the top level of the school, and there should be broad representation all the way from administration representatives to faculty to students on that committee, and that they should deal aggressively with human relations issues on their own.

For a long while they resisted that—they just did not want to have such an organization. But when we kept up the pressure, they finally acquiesced: one day they told us they had appointed a human relations committee. Yet when we asked them who was running it, it turned out to be the existing administrative staff of the school, which just added human relations to its many other responsibilities. So it wasn't a specific committee, and of course nothing ever happened. But New Trier has always had a problem—I don't know if they realize historically or even today that they have a problem when it comes to dealing with African American children. I don't know if there's a problem with other cultures, or what. But the stories that I hear, still hear, from kids coming out of New Trier—there are kids coming out of Glencoe who don't even want to go. It's just not a good experience for African American children. And they've never gotten it; they've never really understood it, what it was all about, and what it means. The focus is so much on academics that they just don't seem to understand the important role that they play in forming young lives and giving them something other than academics and a way to make a lot of money.

Following my years on the Glencoe School Board, I served on a committee for New Trier Township that was responsible for doling out public funds to charitable organizations. My impression is that there is more need in the township than most people think.

Then in 1992 I got a call from a couple of community leaders here in Glencoe who asked me if I would be willing to have my name put up for president of the village. I think to some extent it was based upon the fact that I had taken charge of the closing of West School, which, as challenging as that was, we were able to get done with minimal disruption. After considerable thought, I said yes. I actually waited until the last day that the caucus was accepting applications, because I just wasn't sure that I wanted to do it. As a matter of fact, I talked to both of my daughters, I talked to Frankie, and my reluctance was that I felt that I had already made a contribution to Glencoe, but it was my younger daughter who gave me a perspective that I had not thought of. She asked me if I felt that there would ever be another African American president of the Village of Glencoe. And I said, I really don't know, I hadn't thought of it. She said, suppose that there never is, and you passed up this opportunity. I said, you're right. And so I did it.

The village president sets the agenda for the community in the sense that he decides what his priorities are going to be, how he wants to move the village government along and in what direction. Being an actuary, I tended to look at the financial part of what was going on very closely, and I was very interested in it because I understood it. So I focused a lot of my attention on improving the finances of the village. There have been presidents whose home phones ring off the wall; mine did not, because I didn't deal with the community in that way. I represented the community, but I did not see myself as someone who became involved in village operations. So I encouraged people to deal directly with the administration. Yet where I felt that individual issues, such as zoning, called for attention, I felt that I should represent people. I wanted to hear about community issues, such as a whole area with flooding problems. So I tended to be more of a "big issue" person than an individual problem solver.

Early in my presidency we brought in an experienced person who was a trainer. We began a six-month cycle of training Public Safety officers on various aspects of cultural diversity, human relations, things of that nature. The officers are very close to the trainer; the trainer gets calls from them when they have situations where they

The Little Migration

President Webb maintaining a Glencoe tradition. *Glencoe Historical Society.*

are uncertain about which way to go. That's what we wanted to accomplish, to develop that rapport. That was a situation where because of my own personal interest I reached out and said that this is something that we need to do.

I also let it be known early on that I would like to see more African Americans in visible Public Safety jobs, out on the street. When I appointed people to the three-person Public Safety Commission, I made sure that there was always at least one African American on that commission. Most recently, at the end of my tenure, there were two African Americans on it. It is that commission that does the interviewing and recommending, and so they essentially do the hiring. The staff does some screening, but in the final analysis, all the serious candidates go through the commission. We have had some outstanding people on the commission; one was a former assistant U.S. attorney, another is an African American resident who was with the Chicago Police Department for a number of years.

As for hiring African Americans for public safety officer positions, Glencoe has really tried. But we are in competition with Chicago; most of the African Americans who apply live in Chicago, and Chicago pays very, very well. They also have a lot of flexibility for promotion. Yet while Glencoe is a wonderful place to work in and to live in, to people living in Chicago it is not always attractive. So I know that they tried for eight years, but the fact is that they were not as successful as I had hoped they would be.

This is the same situation we faced when I was on the school board. I traveled across the country, trying to recruit African American teachers. We would go to black colleges, to Atlanta, to New Orleans, around the country, trying to encourage prospective graduates to consider Glencoe. We did that only after we found that it was next to impossible to attract African American teachers from the inner city to come out here. But we were not successful. People see the housing prices; a lot of African Americans still feel more comfortable living in an African American community. So that was not as attractive to some people either. So it is difficult to bring diversity into government employment, whether it is the board of education or village government.

I had a pretty good four years as president, with a lot of support in the community, and so I decided to run for a second term. It was then that I began to understand why politicians want a second term—it takes you a while to really get the motor running, to have the base that you need, the support system that you need and to see what the issues are and what the problems are. It takes four years. Had I left after one term, I would have left a lot of things undone that I had put into position. So I needed that second four years to make it happen. It had nothing to do with race or anything else at that point; it had to do with making a contribution and getting the job done.

During the time that I was village president, Glencoe joined the National League of Cities, and I became a member of the U.S. Conference of Mayors. With membership in the League of

James Webb and Wilson Rankin, 1996. *Village of Glencoe.*

Cities, I felt that there was an opportunity to learn things from other communities similar to Glencoe, ideas and experiences I could bring back here that would be of benefit to the community. I think I joined the Conference of Mayors for a different reason: I wanted to take Glencoe to another level. I really wanted the rest of America to know about this community. It means a great deal to me; I think it's a great community, and I wanted others to know about it. I wanted mayors to be aware of who we are and so forth. It is interesting the extent to which you can make that happen, because people meet you, and they ask, tell me about Glencoe. It gives you the opportunity to tell your community's story.

In 1994, a year after I took office, the village observed its 125th anniversary. I felt that we ought to celebrate, and so I appointed a task force. We came up with a number of ways to commemorate the anniversary, which we did throughout the year, culminating in a community dinner at the Chicago Botanic Garden that featured national correspondent Ann Compton, who grew up in Glencoe.

Because of Glencoe's membership in the National League of Cities, we decided that year to apply for the Cultural Diversity Award given to communities under ten thousand. The League gives that award in conjunction with the National Black Caucus of Local Elected Officials, and it turned out that we had quite a bit of competition. But we submitted a strong application that stressed our diverse roots, as well as the creativity and enthusiasm of our 1994 Celebration Committee. We were delighted when Glencoe won that award at the League's 1995 annual meeting in Washington.

I was always hoping that there would be growth in the African American population from 3 or 4 percent to a little higher at least, so the present trend concerns me. The fewer there are, the less the chance is that you're going to get more African Americans to come to the community. I've always felt, and we talked about this at the Home Investments Fund, that as we were trying to create "open communities," we talked a lot about that critical mass. We felt that if we could get about half a dozen African American families into a heretofore all-white community, that that's probably a sufficient number to say, they're not going to chase them away one by one, they'd have to chase six of them away. So critical mass is important. But you don't have that kind of issue here in Glencoe. No African Americans like to feel isolated, so the more you have in a community, the more likely you are to attract other African American families.

The community is changing, and I have some concern about that. Not only has our population slightly declined—in 2000 it was 8,762—but we used to have more of a socioeconomic cross section, and that's not the case any longer. A number of the smaller houses are being torn down and replaced with the expensive houses. I'm sure that our demographics now are quite different than they were before. Generally, there will be a few African Americans buying the most expensive houses, but not in the same degree as in the community in general. This will have an impact on our cultural diversity, our racial diversity, on economic diversity and a diversity of attitude. Are we going to attract people who then don't know their neighbor? Stick in their homes? Not participate and volunteer in the community? And not truly become a part of the community?

And that is what Glencoe has been known for historically. When I was president, I saw new residents when they were directly affected by something, but I didn't see them volunteering. Sitting from my vantage point, trying to find people help get a job done, I found myself going back continually to the same people. They tended to people I knew for years, the same people who were volunteering ten and twenty years before. I tried very hard to find new faces, and I just couldn't find them. They volunteer for school activities when their children are there, but we did things in addition to that. It wasn't just the things that directly affected us. I think the attitude sometimes is, I'm not old, why do I have to deal with old people? I'm not poor, why should I bother with that? So there is still an important role that a human relations organization can play, and that is ensuring that this community retains something of its diverse character of the past, even if it has to be done unofficially. This goes back to the basics, that positive human relations results from positive interaction, and you do those things that encourage people to mix, to meet, to get to know one another and to like one another. And it comes from that. Most of my close friends in Glencoe these days, honestly, are people that I met working in the human relations area. It is a beautiful community, a great place to live and to raise your children, it's good for you economically if you invest here, it is a solid community, strong, in no danger of going in the other direction. The only thing that we need to be careful about is to make sure the community, defined as the sum of its people, retains that character that causes each one of us to reach out to others.

Notes

1. *The Conservator*, September 9, 1883.
2. "First Story of Glencoe Homes Association," *Real Estate Investor of Chicago* (December 1927): 5.
3. Theodore W. Hild, "The Great Transformation," *Historic Illinois* 28, no. 5 (February 2006): 7.

Part I: "There Is No Suburb Like Glencoe"

4. Patricia O'Keefe, ed., *The History of New Trier Township 1850–2001:150 Years of Grassroots Government* (Winnetka, IL: self-published, 2001), 5–6; *Seventy-Five Years of Glencoe History* (Glencoe, IL: Glencoe Historical Society, 1944), 3–7, 11; Marjorie Thulin, ed., *Glencoe Lights 100 Candles, 1869–1969* (Glencoe, IL: Glencoe Historical Society, 1969), 5–10.
5. O'Keefe, *History of New Trier*, 7, 28; *Seventy-Five Years*, 3–4; Thulin, *Glencoe Lights 100 Candles*, 5–6; Frank A. Windes, *Historical Glimpses of Hubbard Woods* (Winnetka, IL: self-published, 1943).
6. O'Keefe, *History of New Trier*, 7, 9, 28; *Seventy-Five Years*, 4, 11; Thulin, *Glencoe Lights 100 Candles*, 6, 9, 11; Michael Bartlett, *Celebrating One Hundred Years: Skokie Country Club 1897–1997* (Glencoe, IL: self-published, 1997), 14, 16; Document No. 155226, Cook County Recorder of Deeds, Chicago.
7. Louise Culver Van Horne, *Culver-Gehan Family History* (Arlington, VA: self-published, 1997), 58–61, 71, 73–74; *Sheridan Road News-Letter*, March 2, 1900; Document No. 129723, Cook County Recorder of Deeds, Chicago.
8. O'Keefe, *History of New Trier*, 28; Document No. 436871, Cook County Recorder of Deeds, Chicago.

9. Thulin, *Glencoe Lights 100 Candles*, 10; James K. Calhoun, "Historical Sketches of Glencoe, Illinois," 1909. Located in the collection of the Glencoe Historical Society, privately published.

10. *Seventy-Five Years*, 30; Van Horne, *Culver-Gehan Family History*, 124–127; *Glencoe News*, January 5, 1929.

11. A.T. Andreas, *History of Chicago*, volume II (Chicago: self-published, 1885), 109.

12. Ralph Nelson Davis, "The Negro Newspaper in Chicago," master's thesis, University of Chicago, 1939, 26.

13. *Glencoe News*, March 12 and July 21, 1927, January 5, 1929, January 29, 1942; Walter Paulison, *The Tale of the Wildcats* (Evanston, IL: Northwestern University Alumni Association, 1951), 25; Glencoe Historical Society, *Glencoe, Queen of Suburbs: Three Tours* (Glencoe, IL: Glencoe Historical Society, 1989).

14. Interview with Nancy King, 2003; Thomas Hutchinson, comp., *The Lakeside Annual Directory of the City of Chicago* (Chicago, 1878–84); Document Nos. 559474 and 560565, Cook County Recorder of Deeds, Chicago.

15. *Lakeside Annual Directory*, Chicago, 1878–84; Rose Dennis Booth, "Highlights of Early Glencoe," 1938, located in the Glencoe Historical Society collection; Patricia Tennison, "Assumptions on Race Don't Hold in Glencoe," *Chicago Tribune*, Suburban Trib North Shore, February 9, 1977; Glencoe Union Church, *The Reminder*, July 22, 1893, located in the Glencoe Historical Society collection.

16. Albert O. Olson, "The History and Naming of Hogarth Lane," 1941, located in the Glencoe Historical Society collection.

17. *Sheridan Road News-Letter*, July 6, 1900; Thulin, *Glencoe Lights 100 Candles*, 6.

18. *National Magazine* 15 (November 1891–April 1892): 189–90.

19. Courtesy of the Glencoe Historical Society.

20. Allan H. Spear, *Black Chicago: The Making of a Negro Ghetto 1890–1920* (Chicago: University of Chicago Press, 1967), 6–7, 14–15.

Part II. "Then Everyone Was Your Father, Everyone Your Mother"

21. *Chicago Tribune*, August 2, 1884; I.C. Harris, *The Colored Men's Professional and Business Directory of Chicago* (Chicago, self-published, 1885), 13; Thomas L. Safran, "A Slum Clearance Project, or, The Development of

the Monroe-Vernon Park in South Glencoe, Illinois," term paper, New Trier High School, 1969, 5.

22. *The New York Public Library African American Desk Reference* (New York: John Wiley & Sons, 1999), 150; St. Paul AME Church, *105ᵗʰ Anniversary Celebration* (Glencoe, IL: self-published, 1989).

23. Weston A. Goodspeed, and Daniel D. Healy, *History of Cook County, Illinois* (Chicago: Goodspeed Historical Association, 1909), 420; City of Chicago, Commission on Chicago Landmarks, *Quinn Chapel* (Chicago: Commission on Chicago Landmarks, 1977); Richard R. Wright Jr., *Centennial Encyclopedia of the African Methodist Episcopal Church* (Philadelphia, PA: self-published, 1916), 103, 301–302; A.T. Andreas, *History of Chicago*, volume I (Chicago: self-published, 1885), 333–34.

24. The AME Church, which opened in 1870, was located near the campus of Lake Forest College. When given permission, students from the college and from Lake Forest Academy regularly participated in Sunday evening services at the church, those preparing for the ministry occasionally delivering sermons. White neighbors, who appreciated the sincerity and simplicity of AME worship, also attended services and Sunday school there. Arthur Miller and Charles A. Miller, *African American History in Lake Forest: A Walking Tour* (Lake Forest, IL: Lake Forest College, 1997); Edward Arpee, *Lake Forest, Illinois: History and Reminiscences 1861–1961* (Lake Forest, IL: Lake Forest-Lake Bluff Historical Society, 1964, 1991), 76, 118–119, 149.

25. Document No. 974433, Cook County Recorder of Deeds, Chicago.

26. *Seventy-Five Years*, 21; St. Paul AME Church, *120ᵗʰ Anniversary Celebration* (Glencoe, IL: self-published, 2004); interview with Wilson Rankin, 2003.

27. John D. Buenker, *The History of Wisconsin*, volume IV, *The Progressive Era, 1893–1914* (Madison: State Historical Society of Wisconsin, 1998), 201; "Colored Church Fully Organized; Reverend Jesse Woods of Chicago Presides at Meeting," *Wisconsin State Journal* [Madison] (April 9, 1902), courtesy Ann Waidelich; Joe William Trotter Jr., *Black Milwaukee: The Making of an Industrial Proletariat, 1915–45* (Urbana: University of Illinois Press, 1984), 64–65, 128; Barbara J. Buchbinder-Green, *Evanston: A Pictorial History* (St. Louis, MO: G. Bradley Publishing, 1984), 45; *Ebenezer AME Church, 1882–1965* (Evanston, IL: self-published, n.d.); Kevin B. Leonard, "Paternalism and the Rise of a Black Community in Evanston, Illinois: 1870–1970," master's thesis, Northwestern University, 1982, 11; *Afro-American Budget*, January 1890, Northwestern University Archives; Penelope L. Bullock, *Afro-American Periodical Press, 1838–1909* (Baton Rouge: Louisiana State University Press, 1981), 88–90.

28. *Lakeside Directories* (Chicago, 1878–86); *Sheridan Road News-Letter,* June 10, 1899, June 8, 1900; *Seventy-Five Years,* 29.

29. Booth, "Highlights of Early Glencoe"; *The North Shore Directory* (Evanston, IL: Evanston Index Company, 1904), 601; interview with Wilson Rankin, 2003; Bartlett, *Celebrating One Hundred Years,* 25.

30. Interview with Wilson Rankin, 2003.

31. Interviews with Wilson Rankin, 2003, and Wendell Carpenter, 2005; Brad Snyder, *Beyond the Shadow of the Senators: The Untold Story of the Homestead Grays and the Integration of Baseball* (Chicago: Contemporary Books, 2003), 35.

32. Interview with Kay Konradt, 2003.

33. *North Shore News-Letter,* February 20, 1909; interview with Nancy King, 2003.

34. *Bumstead's Evanston City and North Shore Directory 1912–1913* (Chicago: Bumstead & Co., 1912); interview with Bruno Bertucci, 2005.

35. *Bumstead's Directory 1912–1913*; interview with Wilson Rankin, 2003.

36. *Glencoe News,* December 22, 1988; interview with Gloria Foster, 2005.

37. *Glencoe News,* July 5, 1973; interview with Louise Gibbs, 2005.

Part III. "No One Was Ever More Devoted to the Cause of Racial Justice"

38. *Who's Who in Colored America 1941–44* (Brooklyn, NY: Thomas Yenser, 1944), 325; Harris, *Colored Men's Directory,* 31; Miles L. Berger, *They Built Chicago: Entrepreneurs Who Shaped a Great City's Architecture* (Chicago: Bonus Books, 1992), 93–104; Christopher Robert Reed, *The Chicago NAACP and the Rise of Black Professional Leadership, 1910–1966* (Bloomington: Indiana University Press, 1997), 51–58, 76–77; Harold F. Gosnell, *Negro Politicians* (Chicago: University of Chicago Press, 1935), 163–95; Elliott M. Rudwick, "Oscar DePriest and the Jim Crow Restaurant in the U.S. House of Representatives," *Journal of Negro Education* 35, no. 1 (Winter 1966): 77–82; *Chicago Sun-Times,* November 10, 1961; *Chicago Defender,* November 11, 1961; interview with Beverly Carr and Doris Wilson, 2006.

39. *Glencoe News,* April 19, 1973, November 11, 1976.

40. Interview with Wilson Rankin, 2003.

41. Daniel H. Burnham and Edward H. Bennett, *Plan of Chicago* (Chicago: Commercial Club, 1909), 35.

42. Burnham and Bennett, *Plan of Chicago*, 34.
43. Thomas L. Safran, "A Slum Clearance Project, or, The Development of the Monroe-Vernon Park in South Glencoe, Illinois," term paper, New Trier High School, 1969; Glencoe Homes Association, papers, Glencoe Historical Society; *Real Estate Investor* (December 1927), Glencoe Historical Society; Case File No. 490748, Clerk of the Circuit Court of Cook County Archives, Chicago; *Glencoe News*, November 3, 10, 17, 24, December 1, 1928, August 31, 1929, April 19, July 5, 12, 1930, October 23, 1931, May 6, September 2, 1932, May 10, November 1, 1935; interview with Robert E. Everly, 1988. Glencoe suffered from the Depression in numerous ways. New construction dropped over 95 percent, from two or three new residences per week to two or three per year; each of the two banks in town closed abruptly, leaving many families suddenly penniless; and at one point both the Glencoe schools and New Trier High School were days away from shutting their doors due to lack of tax receipts.
44. Gloria M. Clark, Nancy Ann King, Sarah O'Kelley and Wilson Rankin, *History of St. Paul AME Church* (Glencoe, IL: self-published, 1989); *Glencoe News*, September 20, 1930, April 25, 1931; Case File No. CR 58719, Clerk of the Circuit Court of Cook County Archives, Chicago; *Cases of the Supreme Court of Illinois*, vol. 355, (1934), 358–66; interviews with Wendell Carpenter, 2005, Wilson Rankin, 2003.
45. Village of Glencoe, Building Permit, 336 Washington Avenue, February 2, 1931; Bonita Billingsley Harris, "Charles Sumner Duke," in Dreck Spurlock Wilson, *African American Architects: A Biographical Dictionary, 1865–1945* (New York: Routledge, 2004), 97–98, 127–29; *Who's Who in Colored America*, 1928–29, 117; interview with Tim Samuelson, 2005.
46. Gosnell, *Negro Politicians*, 21.
47. A.L. Foster, "Twenty Years of Interracial Goodwill Through Social Service," in *Two Decades of Service* (Chicago: Chicago Urban League, 1936); Arvarh E. Strickland, *History of The Chicago Urban League* (Columbia: University of Missouri Press, 1966, 2001), 104–113, 125–28,136–54, 179; Nancy J. Weiss, *The National Urban League, 1910–1940* (New York: Oxford University Press, 1974), 247; *Chicago Tribune*, "Huge Housing Plan Sent to Washington," February 25, 1934.
48. Case No. 41C 6335, Clerk of the Circuit Court of Cook County Archives, Chicago; *Chicago Sun*, "Court Opens Glencoe Beach to Negro Family," July 10, 1942; *Chicago Defender*, "Forbids Glencoe to Deny Use of Beach to Fosters," July 11, 1942; *Glencoe News*, August 7, September 25, 1941, July 9, 1942; interview with Leonard Foster, 2004.

49. *Chicago Defender*, "A.L. Foster," editorial, June 3, 1968; *Chicago Sun-Times*, May 30, 1968; *Glencoe News*, June 10, 1968.

Part IV. "Why Don't They Let Us Fly Planes and Run Ships…"

50. Richard Wright, *Native Son and How "Bigger" Was Born* (New York: Harper Perennial, 1940, 1993), 21.

51. Charles E. Francis and Adolph Caso, *The Tuskegee Airmen: The Men Who Changed a Nation* (Boston: Branden Publishing Co., 1997), 121–22.

52. Elizabeth Warren, "Roger Bartlett Brown," *A Memorial to Glencoe's War Dead: Biographical Sketches of Men Who Died in the Service of Their Country in the Twentieth Century* (Glencoe, IL: self-published, 1993).

53. Jacqueline L. Harris, *The Tuskegee Airmen: Black Heroes of World War II* (Parsippany, NJ: Dillon Press, 1995), 26–27.

54. "People moved slowly then. They ambled across the square, shuffled in and out of the stores around it, took their time about everything. A day was twenty-four hours long but seemed longer," Harper Lee, *To Kill a Mockingbird* (New York: Warner Books, 1960, 1982), 5; Writers' Program, *Alabama: A Guide to the Deep South* (New York: Richard R. Smith, 1941), 269–71; Linda and Charles George, *The Tuskegee Airmen* (New York: Children's Press, 2001), 11–12.

55. George, *Tuskegee Airmen*, 10–11; Bradley Graham, "A Fourth Star for a Fighter," *Washington Post*, December 10, 1998; Benjamin O. Davis, *Benjamin O. Davis, Jr., American: An Autobiography* (Washington, D.C.: Smithsonian Institution Press, 1991), 18–20, 27–28, 38, 51–54. When young Davis needed a Congressional appointment for admittance to West Point, his father turned to Representative Oscar DePriest, still the only black member of Congress. As a result, Davis moved to Chicago long enough to qualify as a constituent of DePriest, who then made the appointment. Of his experience at West Point, General Davis wrote: "Except for the recognition ceremony at the end of plebe year, I was silenced for the entire four years of my stay at the Academy. Even though West Point officialdom could maintain that this silence had no official basis, they knew precisely how I was being treated and that I was the only cadet in the corps treated in this manner. When we traveled to football games on buses or trains, I had a seat to myself; even as a first classman (senior), when we traveled to Fort Benning, Georgia, and Fort Monroe, Virginia, I lived alone in whatever quarters were provided, usually large enough for

two or more cadets. Except for tutoring some underclassmen after my plebe year, I had no conversations with other cadets. The situation was ridiculous, but in no way was it funny. To this day I cannot understand how the officials at West Point and the individual cadets, with their continually and vociferously stated belief in 'Duty, Honor, Country' as a way of life, could rationalize their treatment of me."

56. Tuskegee Airmen, Inc., "Who Were the Tuskegee Airmen?" www.tuskegeeairmen.org.

57. While Captain Tresville grew up at Fort Benning, Georgia, his appointment to the academy in 1939 came from Representative Arthur Mitchell of Illinois, successor to Representative Oscar DePriest. Francis and Caso, *The Tuskegee Airmen*, 315; Lynn M. Homan and Thomas Reilly, *Black Knights: The Story of the Tuskegee Airmen* (Gretna, LA: Pelican Publishing Company, 2001), 117.

58. "100th Fighter Squadron, Missing Air Crew Report on 2nd Lt. Roger B. Brown, 15 June 1944," courtesy of Tuskegee Airmen, Inc.

59. George, *Tuskegee Airmen*, 22; Francis and Caso, *Tuskegee Airmen*, 132–33, 315. Captain Tresville became the first African American graduate of West Point to lose his life in combat.

60. St. Paul AME Church, "Memorial Service for Lt. Roger B. Brown, November 6, 1944," courtesy of Gloria Foster.

61. Quoted in Paul Stillwell, ed., *The Golden Thirteen: Recollections of the First Black Naval Officers* (Annapolis, MD: Naval Institute Press, 1993), 279–80.

62. Stillwell, *The Golden Thirteen*, vii–ix, xv–xxviii, 144–67, 264–82; *Life*, April 24, May 15, June 5, 1944; John Bartlow Martin, *Adlai Stevenson of Illinois* (Garden City, NY: Doubleday & Company, 1976), 212; Ron Grossman, "Breaking a Naval Blockade: 43 Year Later, Great Lakes Honors Its First Black Officers," *Chicago Tribune*, July 8, 1987; Stephen Price, "First Black Naval Officers Finally Get Smart Salute," *Chicago Tribune*, March 9, 1994; Anne Marie Ligas, "Navy Honors Glencoe Man Who Broke Color Barrier," *Glencoe News*, March 24, 1994; George Cooper obituary, *New York Times*, June 1, 2002; Lisa Black, "First Black Navy Brass Honored for Service," *Chicago Tribune*, May 24, 2005.

Part V. "Where Are All the Black People?"

63. *Glencoe Memo*, July 1982; interview with Robert B. Morris, 2005.

64. Horatio Alger Association, *Only in America 1981; Anniversary Issue 2001*, www. horatioalger.com.

65. *Who's Who Among Black Americans*, 5th ed. (Lake Forest, IL: Educational Communications, Inc., 1988), 373; *Time*, "Making Black Beautiful," December 7, 1970; *Wall Street Journal*, "George Johnson: Helping Hand," November 29, 1999; *New York Times*, "Johnson Products Trading on Amex," January 15, 1971.

About the Author

During a long career in business, Robert A. Sideman has also written, lectured and testified on Chicago history and historic preservation. He has contributed to several books on the subject and for many years edited a newsletter on Chicago architecture. In 2007, he delivered "A Time of Promise: African Americans in Chicago 1865–1885," at the Conference on Illinois History. The father of two children, he resides in Glencoe.

Please visit us at
www.historypress.net